THE NAKED EYE

CHARLES SAATCHI'S NEW BOOK BASED ON EXTRAORDINARY
UNPHOTOSHOPPED IMAGES

THE NAKED EYE

CHARLES SAATCHI

Booth-Clibborn Editions

Contents

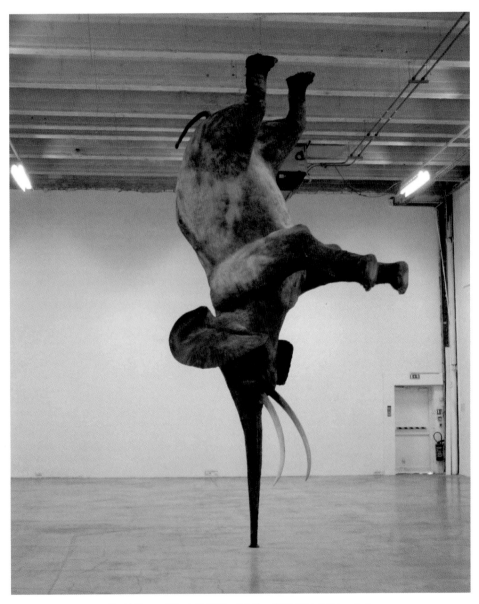

Daniel Firman, *Würsa à 18,000 km de la Terre*, 2008, Palais de Tokyo, Paris

French artist Daniel Firman created this taxidermic elephant balancing on the tip of its trunk. The artist based his work on the calculation that the elephant could manage this feat on a planet with a circumference of 18,000 km (because of its weak gravitational pull). The life size and hyper-realist sculpture was created with taxidermist Jean-Pierre Gérard.

Elephants are more interesting than most humans.

Although it remains the case that elephants cannot balance upright on their trunks, they are amongst the world's most intelligent species. Aristotle was the first to point out that the elephant is the animal which surpasses all others in wit or mind.

Elephant brains are larger than any other land animal, and though the largest whales are twenty times the size of a bull elephant, their brains are only twice the size of the elephant's. It appears that an elephant brain cortex has as many neurons as a human brain, suggesting convergent evolution.

Elephants experience a wide variety of emotions and skills – grief, learning, mimicry, play, humour, use of tools, compassion, cooperation, awareness, memory. It makes the notion of these great beasts being slaughtered for their tusks even more repellent.

Elephants have the closest-knit societies in the animal kingdom, and can be separated only by death or capture. No wonder I still sob all the way through *Dumbo* when he is taken away from his mother. Elephants have been recorded as creating a shallow grave for a family member who had died, and covering it in leaves.

I was intrigued by the report of a ranch herder in the wild of Africa whose leg was broken by a grumpy bull elephant. The bull's female partner used her trunk to lift him under the shade of a tree, and guarded him for the day until rescue arrived. He told how she would gently soothe him by stroking him with her trunk.

Of course it's best to remember if you are planning a trip to see elephants in the wild, they are also considered among the most dangerous animals on the planet.

That is why they have no natural predators, other than a man with a gun. Even then, if the idiot with the gun comes across an elephant during Musth, when a male elephant's hormones are peaking at sixty times higher than normal, not only can they run 100 metres faster than Usain Bolt, but they have been known to charge through two direct hits from a .460 Weatherby Magnum, and trample the hunter to death.

They have been witnessed slinging rhinoceroses 14ft above their heads. Other charming individuals who have tried anchor chains to capture an elephant soon discover that if they get him in the right mood, an elephant is wily enough to angle his tusk into the chain links and pop them. And hopefully, pop the big-game hunter as well.

Of course the most dangerous creature on earth is the mosquito, which can be held accountable for more deaths throughout history than any other living creature.

They are extremely effective at passing on infectious diseases, and Malaria alone can kill 20% of sufferers in severe cases, even with medication.

Other potentially fatal diseases they kindly pass around are West Nile Virus, Roundworms, Tularemia, Dengue Fever and Yellow Fever.

I've never liked swimming in the sea, and my aversion was cemented when I read about the Sea Wasp Box Jellyfish, apparently the most lethally venomous creature in the ocean.

The merest nip from one of these will leave you in excruciating pain, probably enough to wish you'd been killed outright. Some claim that cutting off the limb that has been stung would be preferable in terms of pain-management to leaving it attached.

If you were unfortunate enough to be locked inside its ten-foot-long tentacles, escape attempts would be futile as the venom breaks down the brain's communication with the nerves, paralysing you and stopping your heart beating within 3 minutes.

I wouldn't actually need to be bitten by a Taipan snake to succumb to

a heart attack at the sight of it slithering towards me. Fortunately they are extremely shy and hide from any larger animals that approach.

But if it feels threatened, its toxin is the deadliest on earth, and it likes to inflict multiple bites to ensure an immediate kill.

Taipans tend to inhabit the Australian outback, but I wouldn't take any chances that one of them hasn't wandered into Sydney, next time you're visiting Bondi Beach for a bit of surfing. Best stick to Cornwall.

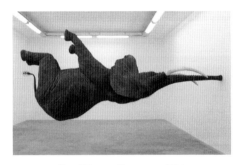

Daniel Firman, *Nasutamanus*, 2012
Fibreglass and polymer, Kunsthalle Wien, Austria

This installation named *Nasutamanus* follows the first balancing elephant (previous page) exhibited in France in 2008. Unlike *Würsa*, *Nasutamanus* is not a real elephant, but was created through consultation with a professional taxidermist to make the look and feel of the sculpture as close to life as possible.

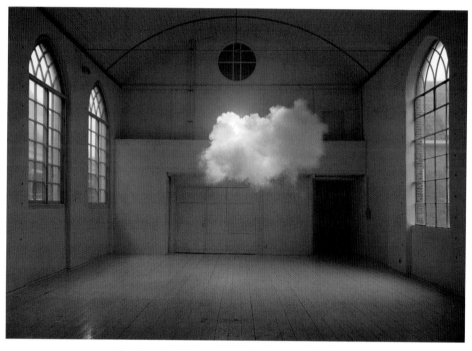

Berndnaut Smilde, *Nimbus II*, 2012, Lambda print, 125 x 186 cm

Dutch artist Berndnaut Smilde used a smoke machine, combined with moisture and dramatic lighting to create a hovering indoor cloud in the empty setting of a sixteenth-century chapel in Hoorn, Holland. "I imagined walking into a museum hall with just empty walls. The place even looked deserted. On the one hand I wanted to create an ominous situation. You could see the cloud as a sign of misfortune. You could also read it as an element out of the Dutch landscape paintings in a physical form in a classical museum hall."

Try telling Bill Rankin that clouds are soft and fluffy.

In 1959 Lieutenant Colonel William Rankin was piloting his U.S. Air Force jet at about 50,000 feet. His plane caught fire, and he was forced to eject. He dropped into a cumulonimbus cloud, full of thunderous rage, that trapped him, flailing him about inside its grip for over half an hour, pelting him with icy hail.

He is the only known survivor of such an encounter, albeit with severe frostbite, blood pouring from his eyes, nose, mouth and ears due to the decompression, and a body covered in welts and bruises from the pummelling hailstones.

Even more miraculously, his parachute was still functioning.

The cumulonimbus is the type of cloud all pilots of aircraft dread encountering. The hail-from-hell that they contain is capable of puncturing the exterior skin of an airplane, the lightning inside the cloud can destroy the on-board electronics, frozen water will coat the plane's wings in ice, and air currents are powerful enough to fling even large airliners upside down.

The sky itself is still an enigma to scientists, and certainly to the rest of us. When you look up at the night sky, light from distant stars takes so long to reach us, we are actually seeing how they appeared hundreds, thousands or even millions of years ago. We are really looking back in time.

And we can only see about 5% of the universe. The rest is made up of Dark Matter, a mysterious property also known by astronomers as Dark Energy, and it's all invisible to humans.

The sun is a mighty object indeed, producing so much power that every second its core releases the equivalent of 100 billion nuclear bombs.

I am baffled that on Mercury, the planet closest to the Sun, temperatures can reach -280 degrees Fahrenheit. It's something to do with having no atmosphere to trap heat, so the dark side of Mercury, facing away from the Sun, is chillier than you can imagine. But Mercury has no clouds, unlike most other planets, so it's safer for Lieutenant Colonel Rankin than flying his jet around Earth.

Do you recall that in February 2011 NASA discovered an unknown solar system, with six planets orbiting a sun-like star? It is called Kepler-11, after the space telescope that is finding new worlds in the search for alien life. So far it has detected more than fifty planets that are considered to be habitable zones.

Some of these are believed to have an earth-like atmosphere, and the planet Gliese 581d appears to have seas on its surface. Also discovered was a star made entirely of diamonds. The crystallised white dwarf measures over 2,400 miles across and is composed of ten billion, trillion, trillion carats.

Unfortunately for treasure hunters, or rap stars seeking a really eye-catching pendant, it is 50 light years from earth (that's three hundred trillion miles).

The Kepler is an advance on the Hubble telescope, which has given scientists images of various galaxies, and eerie celestial objects that look like enormous, but delicate butterflies.

Captain Kirk and the Starship Enterprise will one day be beaming down onto one of them, and send back nice pictures of their little trip.

The Hubble Space Telescope was launched by NASA in 1990 and has photographed the birth and death of stars, capturing galaxies that are billions of light years away. It has helped scientists estimate the age and size of the universe, and its photograph entitled 'Hubble Ultra Deep Field' shows the furthest galaxies ever seen, about 14 billion years old.

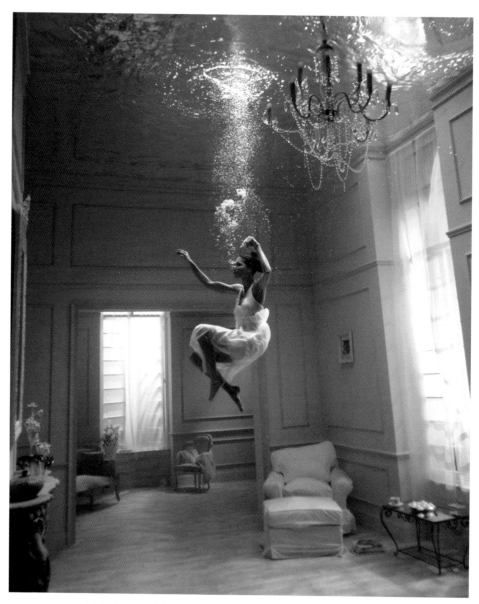

Phoebe Rudomino, Still from Johnson & Johnson's 'Imagine' Total Hydration body wash TV
commercial, HomeCorp., 2006, C-print, 164.34 x 110 cm

Rudomino is a commercial diver and underwater photographer based at the Underwater Stage
at Pinewood Studios. This photograph was taken during a shoot for a commercial and was
part of 'Water on the Lens', an exhibition of underwater set photographs taken at Pinewood.

No man drowns if he perseveres in praying to God, and can swim.

I can barely manage a doggy-paddle, but I'm able to glide effortlessly underwater, and managed to snorkel once off the side of a dinghy.

It was crystal clear sea, and although the coral was spectacular and the fish breathtakingly handsome in an assortment of irridescent hues, I panicked at their proximity, and clambered back on the little boat trying not to cry with embarrrassment in front of my children, who are still too ashamed of me to ever speak of it.

Are you a good diver yourself? If so, perhaps you have visited the SS Yongala shipwreck in the Australian Great Barrier Reef. It sank in a cyclone about 100 years ago, with no survivors.

Apparently, even after being submerged for so long, the ship is in well-preserved condition, sixty kilometres off the coast, and you will be joined on your little swim by many delightfully pretty fish, the type that would no doubt have scared me.

It is also popular as an aquatic centre for the local Barrier Reef Great Sharks, and the deadly Box Jellyfish, the venomous local sea snakes, and the delicately small but ferocious Blue Ringed Octopus, which bites with a little beak and injects its poison. They are all waiting to greet you if you are keen for some exciting underwater snapshots when you next visit Australia.

Another popular dive site is in the Red Sea, where SS Thistlegorm was sunk by German bombs in 1941, carrying guns and ammunition en route for Alexandria. Divers can explore the fully intact locomotives and tanks that were on board at the time the Thistlegorm sank.

You can also examine the rips in the hull made by the two 1,000lb German bombs that caused the ship's demise.

Much exploration still takes place on ocean seabeds around the world by treasure hunters, the most reknowned being Odyssey Marine Exploration. A Florida-based outfit, they discovered the most valuable shipwreck ever found.

All we know is that it's somewhere off the coast of Portugal; they have managed to keep the location a secret still, despite having already recovered 500,000 gold and silver coins worth over $300 million.

The government of Spain believe the lost ship is the Nuesta Senora de las Mercedes, sunk by the British in 1804, killing about 200 crew members. A historical account of the Mercedes says that there were 4,356,519 gold and silver pesos on board at the time, and Spain is trying to claim it all, arguing it should be held in a Spanish museum.

Odyssey Marine lawyers disagree, and feel their client's claim is bullet, or indeed cannonball, proof.

Despite my overarching greed, I am too cowardly to get my snorkel out again and see if I can help myself to some of this swag waiting on the ocean floor.

In truth, I do not believe mankind should be encouraged to prance on beaches, or enter the domains of Sea God Poseidon.

It took us millennia to come slithering ashore; we may not have evolved particularly well, but it is surely preferable to growing gills and fins and reverting to Merpeople. We progressed from the ocean. Why regress now?

If you, like me, are a little disappointed at how miserably man has developed, still as barbaric and cretinous as ever, it's worrying that evolution is not as miraculous as many philosophers have claimed.

And scientists have certainly had long enough to turn their attention to the less fortunate, who can't float, and should have invented a buoyancy pill for us to take before attempting a dip. I always trust my mother's advice: No man drowns if he perseveres in praying to God, and can swim.

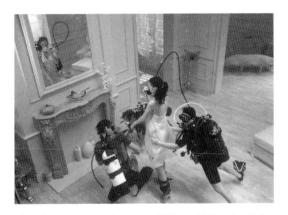

The underwater stage, which opened in 2005, is a globally unique facility and has been used for a vast number of movies, music videos and TV commercials. The permanently filled water tank holds 1.2 million litres of water and is heated to 32 degrees. For the sequence being set up here, an entire house interior was created within the tank. Rudomino specialises in behind-the-scenes underwater stills and video for feature films, TV and commercials.

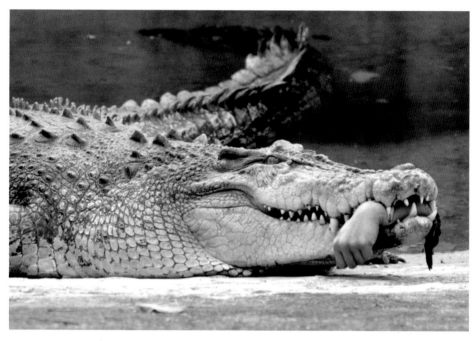

Kaohsiung, Taiwan, April 11, 2007, a Nile crocodile stalks the banks of his enclosure at
Kaohsiung zoo with the forearm of veterinarian Chang Po Yu.

Rather poor Yu than poor me.

Chang Po Yu, a vet and keeper at Taiwan Zoo was attempting to remove a tranquilizer dart from a 440lb, 16ft crocodile, before treating his patient who was refusing to eat.

As he reached through the iron railings, the inadequately sedated crocodile suddenly regained its appetite, lunged and snapped off his arm at the elbow.

As his shocked colleagues applied a tourniquet to a screaming Po Yu, the croc scampered away with the limb in its jaws.

A zoo keeper reached for a rifle to try and kill the crocodile, but missed; the sound of the gunfire fortunately caused the crocodile to drop its prize, and the brave keeper jumped into the pen and retrieved Po Yu's arm.

Packed in ice, it was rushed to the local hospital alongside its distressed owner, and after a seven hour operation was reattached successfully.

Mr Po Yu was obviously delighted, even though his repaired arm is a little shorter; doctors had to remove damaged bone to complete their work efficiently.

Crocodiles who survive (99% of crocodile offspring are eaten by large fish, herons, larger lizards… and other crocodiles) can live to 80 years old.

They swim faster than you, at 25 mph, but you can outrun them even though they can sprint quickly, if you zig-zag as you run away; they can't change course very swiftly, and tire easily on land.

Have you ever understood the expression "crocodile tears"?

I knew it denotes fake sadness, but discovered that the expression came about because tears spill from a crocodile's eyes while it is feasting. And they are not even tears of delight, but simply a physiological response to air being pushed into the glands as it gnaws away.

The first successful reattachment of a human limb was in 1962. Twelve-year-old Everett Knowles was trying to hop a freight train and was thrown against a wall, ripping his right arm clean off at the shoulder.

Knowles walked away from the tracks holding his severed right arm in his left hand. Rushed to emergency surgery, doctors reconnected the blood vessel, pinned the arm and bone, and grafted skin and muscle together, and Everett regained full use of his arm.

In 2007, teenager Kaitlyn Lasitter experienced a horrific accident riding the 'Hell-evator' at the Six Flags Kentucky amusement park. During the ride a cable snapped, wrapping round both her legs, severing both feet.

Doctors were able only to reattach her right foot but she sadly lost her left.

Kaitlyn's medical bills amounting to hundreds of thousands of dollars were held in abeyance until the family's case against the theme park was resolved.

In 2008, Paul Gibbs, a 26-year-old student from Leeds was out camping with friends when he was attacked by three men, and his left ear sliced off.

Because his ear was not found until 17 hours after the attack, surgeons stitched it inside Gibbs' stomach so some of the tissue would re-grow.

The ear could then be reconstructed using cartilage from his ribcage and reattached.

Surgeons can be surprisingly creative in repairing lost limbs.

In a 2007 woodworking accident, Garrett La Fever lost his thumb, but with his agreement doctors removed the big toe on his right foot and grafted it onto his right hand to use as a thumb.

The most extraordinary and ground-breaking surgical miracle I unearthed was about 9-year-old Sandeep Kaur, who in 1994 in India had her face and scalp completely ripped off by a threshing machine that had caught one of her braids.

India's top micro surgeon, Abraham Thomas, was on duty when

Sandeep arrived at the hospital unconscious, with her face in two pieces in a plastic bag.

The surgeon managed to re-graft her face onto her skull and reconnect the arteries.

Sandeep's recovery was complete; she is now working as a nurse, and her experience has been an inspiration for a number of face-transplant procedures.

My best advice? Stay away from crocodiles, jumping onto trains, amusement park rides, camping, woodworking, or standing near a threshing machine.

In Kentucky, the 'Hell-evator' dropped passengers at 56 mph. After the accident it was renamed the 'Superman Tower of Power'. Another ride at Six Flags, 'Kingda Ka' is not just the fastest, but also the tallest roller coaster in the world. A hydraulic launch mechanism rockets the train from 0 to 128 mph in 3.5 seconds.

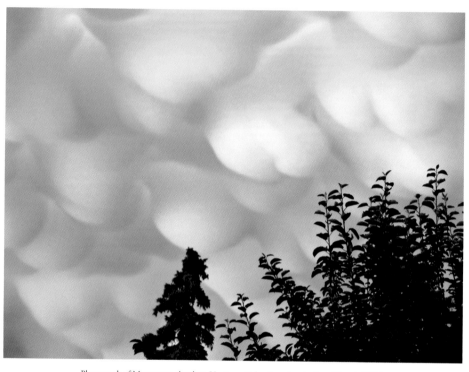

Photograph of Mammatus clouds in Hastings, Nebraska, taken by Jorn Olsen in 2004.

Clouds are classified according to their height and appearance. The 10 basic categories were first agreed by the Cloud Committee of the International Meteorological Conference in 1896 and published as the *International Cloud Atlas*.

Who is the worst mother on earth?

Mother Nature occasionally behaves like a very wicked stepmum, simply because she can. When she wakes up feeling grumpy, she may decide to shower you with hailstones as big as filing cabinets. Known by scientists as megacryometeors, they weigh up to 400lbs (the largest recorded, at 484lbs, dropped on Brazil, in summer, without a cloud in the sky). And no, they are not ejections from airline bathrooms; those are coloured blue from disinfectants. There will be no warning, no sudden high wind or temperature change. It is simply the sky falling on top of you in lumps of ice, big enough to turn you into a crater.

On other days when Nature turns nasty, surprised strollers walking under their umbrellas during a heavy rainstorm have suddenly found it literally raining cats and dogs. And fish. This happened when a tornado hit a lake, flinging fish, frogs, and passing pets, high into the air. In Honduras the occurrence happens on average twice a year, but in genteel Bath in 1894, fashionable locals had a rain of jellyfish land on them as they promenaded along Royal Crescent.

I have never seen a Mammatus cloud, but this is the meteorological term for the cellular pattern of pouches hanging underneath the base of a cloud. The name is derived from the resemblance to bosoms (e.g. mammaries) though clearly, they can momentarily resemble a sky filled with bottoms.

Do you remember the story of the poor pilot of a British Airways flight en route to Málaga, Spain in 1990 who got sucked out of the cockpit window?

Flight attendant Nigel Ogden walked in to offer the Captain Tim Lancaster and his First Officer, Alastair Atchison, a cup of tea. The plane

was rocked by a large bang as Ogden was walking out of the cockpit, and when he turned, here is what he saw: "I whipped round and saw the front windscreen had disappeared when hit by a vicious cyclone and Tim, the pilot, was going out through it.

He had been sucked out of his seatbelt and all I could see were his legs. I jumped over the control column and grabbed him round his waist to avoid him going out completely. His shirt had been pulled off his back and his body was bent upwards, doubled over round the top of the aircraft.

His legs were jammed forward, disconnecting the autopilot, and the flight door was resting on the controls, sending the plane hurtling down very quickly through some of the most congested skies in the world.

Everything was being sucked out of the aircraft: even an oxygen bottle that had been bolted down went flying and nearly knocked my head off. I was holding on for grim death but I could feel myself being sucked out, too. Another attendant rushed in behind me and saw me disappearing, so he grabbed my trouser belt to stop me slipping further, then wrapped the captain's shoulder strap around me.

Luckily, Alastair, the co-pilot, was still wearing his safety harness from take-off, otherwise he would have gone, too. The aircraft was losing height so quickly the pressure soon equalised and the wind started rushing in – at 630 km and -17°C. Paper was blowing round all over the place and it was impossible for Alastair to hear air-traffic control. We were spiralling down at 80 feet per second with no autopilot and no radio."

Ogden could feel his arms being pulled out of their sockets. And because of the altitude, it was extremely cold. The co-pilot managed to get the autopilot back on and the plane came back under their control. Nonetheless, the pilot was still stuck outside the window of the plane.

"I was still holding Tim, but my arms were getting weaker, and then he slipped. I thought I was going to lose him, but he ended up bent in a U-shape around the windows. His face was banging against the window with blood coming out of his nose and the side of his head, his arms were

flailing and seemed about 6 feet long. Most terrifyingly, his eyes were wide open. I'll never forget that sight as long as I live. I couldn't hold on any more, so Simon strapped himself into the third pilot's seat and hooked Tim's feet over the back of the captain's seat and held on to his ankles.

One of the others said: "We're going to have to let him go." I said: "I'll never do that". I knew I wouldn't be able to face his family, handing them a matchbox and saying: "This is what is left of your husband."

Remarkably everything turned out well. Eighteen minutes after the windscreen blew, they were back safe on the ground, some people frostbitten, and with a variety of injuries, but all survived.

I try not to remember this little tale, as I strap the seat belt for take-off on any flight I am simply forced to board, praying that Mother Nature is feeling benevolent that day.

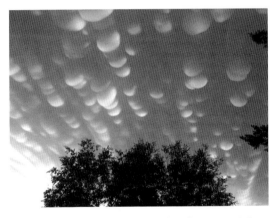

Mammatus clouds in Saskatchewan, Canada, 26th June, 2012. In Iran clouds are good omens. To indicate someone is blessed they say: *dayem semakum ghaim*, which translates as "your sky is always filled with clouds".

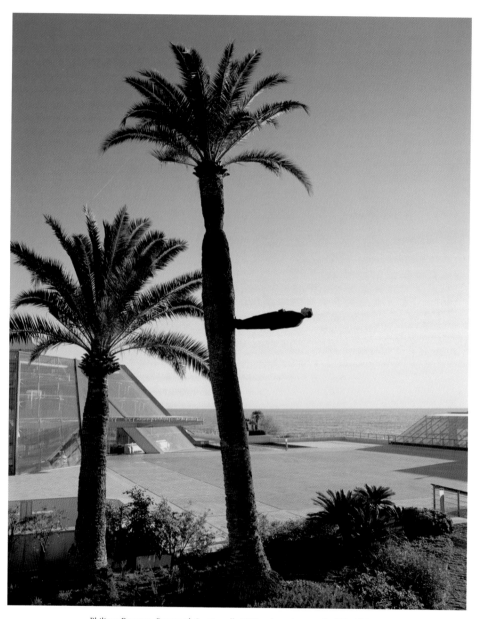

Philippe Ramette, *Promenade Irrationnelle*, 2003, colour photograph, 150 x 120 cm

Ramette's vision is initially sketched out and discussed with his photographer, before being staged and captured on film. Whether suspended in water or in the air, the illusion is rooted in reality: metal devices attach Ramette to his locations, enabling gravity-defying positions.

Would all those who believe in telekenisis, please raise my hand.

I have always fantasized about being able to fly, and relish any occasional dream sequence when I feel as if I am floating up high in a room.

If you share this little peccadillo you may be as intrigued as I was by Daniel Dunglas Home, perhaps the most celebrated and closely scrutinized mediums of the Victorian era, an age famously obsessed with all things spiritual, mystical and supernatural.

Home claimed several talents: he could channel and communicate with spirits from beyond the grave; he was clairvoyant; he was able to manifest various distant sounds – knocks and raps and rumbles – in people's houses; but perhaps most remarkably he claimed to be able to defy gravity.

A number of eyewitness accounts recorded him apparently making inanimate objects levitate – physically rising up, hovering or moving about in the air.

Home first gained notoriety in America, where he emigrated with his adopted family as a young teenager.

Even as a young lad, he was aware of possessing 'powers' of second sight – which seemed a macabre sort of gift, as it was most frequently demonstrated by an uncanny ability to predict the imminent death of people he felt close to.

At age 18, he held his first public séance, convincing the visitors of his credibility by making a table shudder and shake rather violently without touching it.

Home had many important and wealthy supporters, yet he refused to accept payment in return for attending séances.

His was a "mission to demonstrate immortality", rather than to demonstrate a profit. Perhaps he didn't want to give any succour to those

who were vocal in their scepticism.

Was he a fraud? This was the debate that followed him throughout his life. In 1852, the poet and then editor of the *New York Evening Post*, William Cullen Bryant, attended one of Home's séances and later wrote that, 'We know that we were not imposed upon, nor deceived' when Home made a table move so vigorously that even the combined weight of five full-grown men could not hold it down.

However, another eminent writer living in New York – Thackeray, author of *Vanity Fair* – publicly ridiculed Home's demonstrations as "dire humbug, dreary and foolish superstition".

In 1855, suffering from tuberculosis, Home returned to England, where in London spiritualism was all the rage; he had no trouble finding eminent patrons who would support him with fine lodgings and an entrée into society.

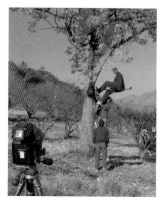

Philippe Ramette rests upon one of the props used to support him in his photographs as he and an assistant prepare for a shot. None of these devices are discernible in the photographs, and so the spectator could be forgiven in mistaking them for works of Photoshop. "Digital enhancement would not allow us to enjoy the reality of the image", says Ramette.

But again, he was not without a number of prominent critics, not least the poet Robert Browning, who attended a séance and promptly wrote a letter to *The Times* to tell the world how, "the whole display of hands, spirit utterances etc., was a cheat and imposure".

He went as far to publish a poem 'Sludge the Medium' to express his displeasure, much to the fury of his wife Elizabeth Barratt Browning, highly respected in her own right, and a stalwart defender of Home.

Nonetheless, Home's fame only grew with his public demonstrations of his pièce de la résistance: levitation.

Home's feats were recorded by Frank Podmore, founder of the Fabian Society: "We all saw him rise from the ground slowly to a height of about six inches, remain there for about ten seconds, and then slowly descend".

And in 1868, Home was purported to have levitated his entire body out of the third storey window of one room, horizontal and feet first, and back in through the window of the room adjoining, in full view of highly credible witnesses, including a Supreme Court judge, and Professor Robert Hare.

In the early 1870s, the chemist and physicist William Crookes conducted a series of experiments on Home's spiritual powers, seeking to determine once and for all the validity of the phenomena.

Crookes' final report in 1874 concluded that there was nothing to suggest any foul play. Effectively, he gave Home's demonstrations a scientific clean bill of health. (And was roundly ridiculed by the academic establishment as a result.)

Home could have duped his sitters in any number of ways, of course, but perhaps the most obvious grounds for his support was the fact that he insisted his demonstrations take place most often in bright rooms, rather than the dimness or near darkness other mediums apparently preferred.

Crookes claimed to have recorded more than fifty occasions in which Home "levitated in good light at least six or seven feet above the floor".

Whatever the veracity of his abilities, Daniel Dunglas Home was a

Victorian superstar. Harry Houdini called him "one of the most conspicuous and lauded of his generation". I imagine he meant magician, or illusionist, however.

Sir Arthur Conan Doyle stated that Home was "unusual in that he had four different types of mediumship: direct voice (the ability to let spirits audibly speak); trance speaker (the ability to let spirits speak through oneself); clairvoyance (ability to see things that are out of view); and physical (moving objects at a distance, levitation etc.)".

At the age of 38, Home retired. He was in poor health – his tuberculosis was advancing and with it, he said, his powers were failing.

He died in June 1886 and has never been seen, nor indeed heard from, since. And so today, there is little celebration of his levitation.

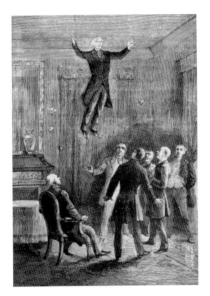

The reported levitation at Ward Cheney's house
interpreted in a lithograph from Louis Figuier, *Les
Mystères de la Science 1887*. Spiritualism had reached
its peak of popularity in Victorian London; even
Charles Dickens and Sir Arthur Conan Doyle were
members of the Ghost Club which was dedicated to
proving the existence of paranormal phenomena.

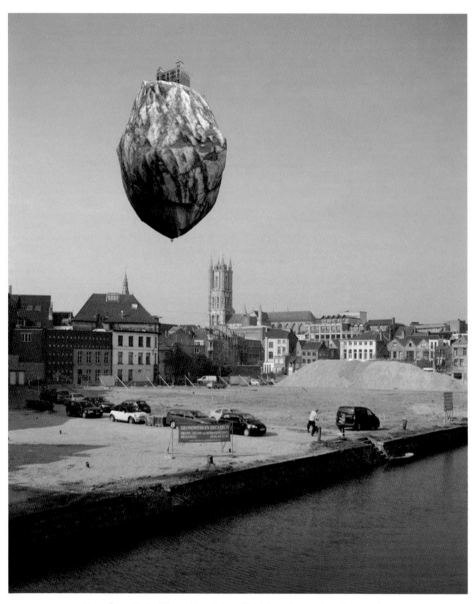

Ahmet Öğüt, *Castle of Vooruit*, 2012, helium-filled balloon floating above the ground at a height of 11 metres and diameter of 8 metres, Ghent.

Making reference to Magritte's *Le Château des Pyrénées* (1961), Öğüt sent up a gigantic helium balloon in the shape of a floating rock, near the Vooruit Arts Centre. He replaced the mysterious castle on top with a replica of the Vooruit building.

Can you name ten towns in Belgium?

Neither can I. I managed Brussels, Bruges (because of the movie *In Bruges*), Antwerp, Ghent, and Spa (home of the Belgian Grand Prix). That's it. I even managed to forget to remember Waterloo, despite the famous Abba hit.

But years ago, I tried to memorize ten famous Belgians, in order to be able to swat anyone dull enough to ask the over-familiar query.

So I have a cracking list of celebrity Belgians, and not just Hercule Poirot. What about Eddy Merckx, voted the most famous Belgian of all, with his five wins in the Tour de France cycle race?

Audrey Hepburn – I can't imagine you knew that. Hergé, creator of Tintin. Adolphe Sax, creator of the saxophone. Plastic Bertrand, creator of the world wide smash hit "*Ça plane pour moi*". In the same vein who can forget Sandra Kim, youngest ever winner of the Eurovision Song Contest. Let's also pay tribute to Leo Baekeland, inventor of Bakelite. And I always enjoyed the sound of Django Reinhardt, pioneer of the two-finger guitar playing technique.

Art lovers are grateful to Belgium for many great artists – Peter Paul Rubens, René Magritte, Anthony Van Dyck, Rogier Van der Weyden, Pieter Bruegel the Elder, Paul Delvaux, and for more trendy followers of fashion, they can offer up painter Luc Tuymans.

I recently found out that Plastic Bertrand keeps himself busy playing Scrabble (obviously much better than I do, as he recently beat an ex world champion). He has his own art gallery. He also grew very, very fat.

Now if I were a show-off, I could bring up many Nobel prize winners, second-tier great tennis players, so-so racing drivers, a 17-time world champion billiard player, many more painters, a couple of footballers, a

fashion designer whose shirt I once bought at Selfridges but never actually wore when I got it home, and a Judo champion.

Sadly I have forgotten their names, as my desire to parade my vast bank of knowledge has been overcome by my senility. I am simply no longer a virtuoso at plucking utterly useless factoids to bore any companions I still have.

Anyone who thinks that Belgium is a bit feeble in the world power stakes has only to learn that they have an army of 47,000 active troops, so they would present a formidable obstacle for a hostile takeover by Switzerland or Liechtenstein. And the Belgian Navy, with its fleet of two frigates, six minesweepers and six support vessels, would almost certainly see off a marine invasion by, say, the Channel Islands.

I am unable to name any Belgian company that is a global leader, but I do know they have chocolate manufacturers who have international demand for their rather sickly over-sweet confectionery.

And as you are particularly cultured and refined, you will be delighted to know that Belgium has the highest percentage per capita of serious art collectors.

Belgium stands tall in one very important area. There are 178 breweries in the country, creating everything from pale lagers, to Lambic beer, to Flemish red blondes; Trappist beers are everyone's favourite, all produced exclusively in Trappist monasteries.

If you cannot get a pint at your local pub you make do with Abbey beers, similar in style to Trappist beer, though not the real thing; they include Belgian brown ale aka dubbel, white ale, amber ale, Flemish sour ale.

At one end of the scale are the Champagne beers, full of soft small bubbles, and at the other end the more straightforward Pils, not particularly distinctive or renowned by connoisseurs.

I don't belong to any Real Ale fraternity, so as long as it's ice cold, pretty much any half-way decent beer does the trick for me.

But I am assured that Belgian breweries produce a Christmas beer, with more alcohol, and liberal spicing, to make the holiday season go down well all over the Belgian towns whose names I can't remember.

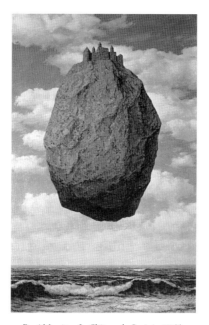

René Magritte, *Le Château des Pyrénées*, 1964, Oil on canvas, 200 x 145 cm

In 1964, Magritte painted the third and final version of this subject matter. Haunting and mysterious, the picture depicts a large rock supporting an old castle, hovering this time above a calm and blue sea – a vista of endless daylight. Harry Torczyner commissioned Magritte to paint this large-scale work to cover up a window in his New York office.

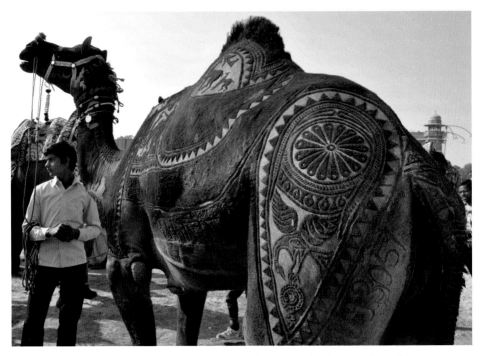

The picture shows an exquisitely decorated 'ship of the desert' at the Bikaner Camel Festival in Rajasthan, India. Held in January, tourists flock from far and wide to see the animals compete to win titles like best decorated camel, best camel hair cut, best camel cutting design, best camel milking and so forth.

What is the most moving art you have ever seen?

For many people around the world, it would be something like the mobile artwork shown on the previous page.

I have never attended a camel beauty pageant, but they are regulars on the calendar throughout India, Pakistan and the Middle East.

The highlight is apparently the Bikaner Camel Festival in Rajasthan, which featured the elegant ungulate pictured.

The camel's hair was grown and groomed for three years in preparation for being trimmed down into intricate patterns and dyed and glossed for dramatic effect.

Are you particularly interested in camels? Me neither. But I did remember that a male dromedary camel with the single hump, has a peculiar organ in his neck, the dulla, a large pink inflatable sac that extends from his mouth when he is seeking a sexual encounter; apparently this sight attracts females and asserts dominance.

They are thoughtfully designed creatures with long eyelashes and ear hair, which together with sealable nostrils form a barrier against sand storms. They can drink thirty gallons of water in one go – and it is not stored in the hump which I foolishly believed was the case, but in fact spreads throughout the whole body in a way only a biologist could comprehend.

You will be intrigued to know that the urine that emerges is a thick syrup, and the faeces so dry they are commonly used as firelighters.

A sport that seldom appears on the schedules of our terrestrial television stations is Camel Wrestling.

Two male camels grapple using their necks to force an opponent to the ground; the motivation to get the camels literally at each other's throats is

to have a female camel in heat presented before them.

There are roughly thirty wrestling events held in Aegean Turkey each year between November and March, if you are in the neighbourhood, and not too squeamish.

Many tourists make a pilgrimage to the Tournament of Champions held at the end of each season, with each fighting camel competing in about ten matches. They fill football stadiums with enthusiastic supporters, as passionate about their sport as Spanish bullfight aficionados.

The owner of a successful camel is invariably a hero of his village, greatly admired by the community, who delight in selecting a name for their local camel that signifies valour, and fearlessness such as Thunderbolt, Destiny or Black Ali.

Crazy Ozer is said to be the greatest fighting camel of his generation. "He doesn't fight with his body, he fights with his brain," his owner claims. "He's simply unbeatable." Sometimes they are named after prominent leaders. When camels George Bush and Saddam Hussein battled it out in 2007 in Selçuk, they tied.

Some camels are admired for their signature moves, expertly pinning their opponent's head with their knees, or sweeping a foe's legs from underneath him, Kung Fu style.

Although encouraged by the Turkish government who believe it promotes the nation's heritage and tradition, the president of the Selçuk Culture and Arts Foundation is struggling to get younger constituents engaged. "All the students are either studying hard to go into university or they sit at home playing video games," he explained.

There are other spectacles across the world worth a trip. I don't have the grit needed to attend El Colacho, the Devil's Jump, celebrated in Spain.

It requires new born babies to be laid upon mattresses on the ground in groups, six infants wide and two rows deep.

Taking place on the street, anybody who wants to participate can have a go at jumping over the baby bedding.

The locals consider the risk to the babies an acceptable burden in order to drive all sins from their previous life and guard the newborns against illness and evil spirits.

Spain is also home to La Tomatina, a food fight that takes place on the last Wednesday in August, when thousands of people take to the streets and throw tomatoes at each other for an entire day.

Only underpants are worn because participants are drenched head to foot in tomato pulp, the street awash with tomato juice, and the shop windows wrapped in protective plastic sheets.

Even diehard Millwall football fans would find the Calcio Fiorentino a bit hardcore; three matches are played in the Piazza Santa Croce in Florence.

The pitch is made of sand, and players are allowed to head-butt, punch, elbow and choke their opponents, though punching or gripping the testicles is considered bad form.

The final takes place on 24th June, in honour of the patron saint of Florence, San Giovanni.

If you attend, be aware that even spectators are occasionally caught up in the heated atmosphere, and have eyes gouged, lips split, are frequently concussed, and require medical assistance.

It makes the Kop End at Liverpool feel like the Royal Opera House.

If you would prefer to trawl some of the world's more interesting beauty pageants, and are unenthused by U.S. contests for glamourised pre-teens, or ladies who have achieved greatness as body builders, I have a few suggestions to inspire you.

Miss Landmine takes place in Angola for women who have lost a limb, competing for the most beautiful single-legged female. The first prize? A leg prosthesis.

Miss Artificial Beauty took place in China in 2004, with the requirement for all competitors to provide a doctor's certificate to prove that they had undergone extensive cosmetic surgery.

Finalists were aged eighteen to sixty-two.

In Thailand they look forward to Miss Jumbo Queen, obviously aimed at a chubby-chaser audience, who appreciate that the winner has to best exhibit the characteristics of an elephant by virtue of her grace and size.

Also self-explanatory is the Miss and Mister Beautiful Bottom, the winner receiving a modelling contract with an underwear manufacturer.

My personal favourite? Miss Russian Army. Used as a recruitment campaign to attract more male volunteers in 2005, the Russian Defence Ministry created the show for transmission on live television. The contestants appeared in uniform and sang songs including the touching lyric: "Since we're soldiers, our first concern is automatic weapons; men come second."

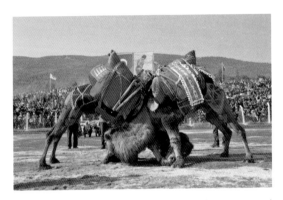

Two male Tülu camels wrestling in western Anatolia. The sport originated 2,700 years ago among ancient Turkish tribes, who noticed that camels wrestled in the wild in response to the motivation of a female in heat.

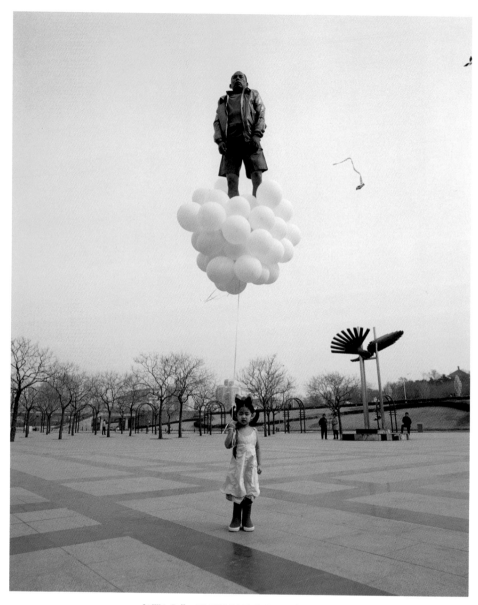

Li Wei, *Balloons 2*, 2009.04.02, Beijing, 176 x 176 cm

Using construction cranes and acrobatic choreography the artist becomes the main character
in a vertiginous drama that is part-angelical/part-action-flick. "Sometimes I am in real
danger – I have to hang myself high with steel wires and people do get a little worried for me
– but I am fine."

Illusion or delusion?

Haven't you always been intrigued by people whose powers and capabilities appear to stretch far beyond the physical and rational limits of ordinary mortals? Magicians, wizards, shamans, illusionists, saints – call them what you will, the feats they perform usually leave us with one question: 'How did they *do* that?'

The word 'stunt' implies a performance for an audience; a feat usually focussed on trying to amaze onlookers, often by putting life at risk – or appearing to. In fact, the words 'death-defying' are often demanded of the stuntman.

Out-and-out daredevils – those individuals who simply set out to do something extraordinary, spectacular and physically terrifying are men like Alain Robert, the human 'Spiderman'. In his solo climbing career he has scaled more than 70 skyscrapers, including the Empire State Building, the Eiffel Tower and the Petronas Towers in Kuala Lumpur, often with no more than chalk dust and gritty determination. He has endured several life-threatening falls, resulting in serious fractures and disabilities; he insists that he also suffers from vertigo. Yet in 2011, at the age of 48, he climbed the 2,717-foot tall, 160-storey high Burj Khalifa in Dubai. It took him six hours.

A century earlier in 1911, Bobby Leach performed one of the earliest – but still most shocking stunts ever – when he decided to hurl himself over the Niagara Falls encased in a steel barrel. He survived the fall, breaking both kneecaps and his jaw. Ironically, the injury that finally killed him was the result of slipping on a piece of orange peel, and contracting gangrene.

For many, Evel Knievel was the twentieth-century daredevil of the

televisual age. Dressed in his trademark flamboyant figure-hugging jumpsuit and cape, Robert Craig Knievel's career lasted fifteen years, performing more than seventy long distance ramp-to-ramp jumps on his motorcycle, leaping over canyons, cars and river rapids.

He entered the *Guinness Book of World Records* for the 433 broken bones he suffered in his lifetime – but his appeal was in large part due to the fact that his stunts were so transparent: no tricks or mirrors involved, just a man, two wheels and a drum-roll. More recently, men like David Blaine and David Copperfield have widened the definition of stunts, performing not as daredevils, but as supreme illusionists, or 'endurance artists'.

In his lifetime David Blaine has been buried alive, 'drowned' alive, frozen alive and, in September 2003, starved himself for forty-four days without any food or other forms of nutrients, inside a transparent Plexiglas case suspended in the air next to the River Thames.

The Dutchman Wim Hof, another specialist performer, is known as the 'Iceman' because he can control his autonomic nervous system and immune response to freezing conditions, through deep meditation. He can withstand the sort of temperatures that would likely kill another man in minutes. He has spent nearly two hours in a bath of ice and in January 2007 he set out to climb Mount Everest wearing nothing but a pair of shorts (a foot injury prevented him reaching the summit).

David Copperfield is a more traditional illusionist. He makes things disappear – but his stunts are performed on a vastly bigger stage and scale than usual. Not content with vanishing a beautiful assistant in front of a packed theatre, Copperfield famously decided to make another great beauty disappear – the Statue of Liberty – and to do so live in front of a global television audience. Despite the distraction of his glamorous locks and superb shoulder pads, he took sleight-of-hand to a remarkable new level.

Today's technology provides any number of possible approaches to making large objects vanish, but at the beginning of the twentieth century, the tools available for such tricks were far more limited. So when in 1918

Harry Houdini brought a live elephant out onto a stage, walked it into a large box, closed the doors, opened them again, and had apparently made the elephant disappear – the world was completely stunned. Professionals believe that Houdini concealed the animal behind a diagonally placed mirror – so that a reflection of a half-empty box presented the mystifying impression he was seeking.

While Houdini intended to create an illusion, he never hoaxed his audience. Around the same time that Houdini's poor elephant was squished behind a mirror in America, two young girls in England took a series of photographs of the fairies that lived in the gardens of their family's home in Cottingley, near Bradford.

In 1919, Sir Arthur Conan Doyle wrote an article claiming they were authentic. While not everyone swallowed the hoax, a certain degree of uncertainty persisted until the early 1980s. The two (by then very grown-up) girls, Frances and Elsie, came clean. "I don't see how people could believe they're real fairies. I could see the hatpins in the backs of them", said Frances.

Arguably, though, the most significant stunts of all are those we have seen fit to call 'miracles' – such as the apparitions of Our Lady of Lourdes. The most famous, outside of biblical times, came about in 1858, when a fourteen-year-old peasant girl – Bernadette Soubirous, later Saint Bernadette – told her mother that she had seen a lady appear in the cave of Massabielle. Apparently the lady asked her to dig beneath a nearby rock and when she did, she revealed a natural spring with healing powers.

The Medical Bureau of the Sanctuary of Our Lady of Lourdes has declared 67 miraculous cures – the 67th occurring in November 2005, when an Italian woman called Anna Santanello was cured of her illnesses after bathing in the waters at Lourdes while on pilgrimage. Before we get too sentimental, sixty-seven cures is not an overwhelming success rate out of the thousands of pilgrims who visit each year seeking heavenly intervention.

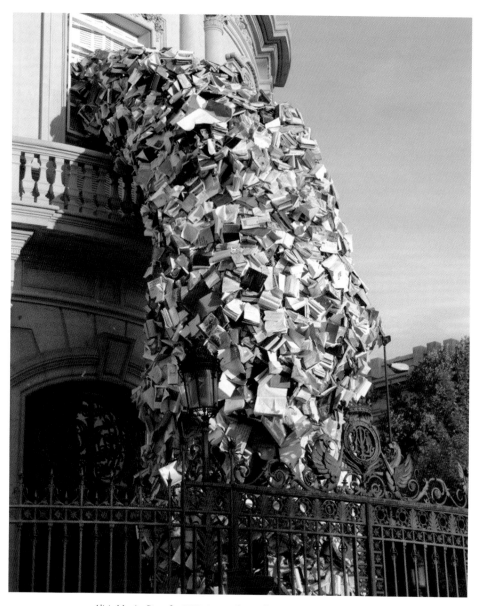

Alicia Martín, *Biografías*, 2005, site specific installation, Casa de America, Madrid

The Spain-based artist's sculptural installation depicts a cavalcade of books streaming out of the side of a building. So far, there have been three site-specific installations of the massive sculptural works in this series known as *Biografías*, each featuring approximately 5,000 books sprawled out around and atop one another.

Books are a mighty bloodless substitute for living.

Robert Louis Stevenson held this somewhat cynical viewpoint about the merits of both writing, and reading. As an example, he would cite the endless supply of new books constantly being published about chess. To him this was the purest distillation of the unnecessary.

There are currently 20,000 books written about the game, but if you are seeking to have a book published, don't let this figure daunt you. It is clearly a market with a beguiling capacity to attract an audience, and as an incentive, somebody has yet to write *Cheque Mate*, a penetrating look at the possibly murky finances of the chess world, set against a daringly erotic narrative.

It will be hard to believe, but the best-selling book of all time may not be the one you're holding. *The Bible* is believed to have sold over three billion copies, with *The Qur'an*, and *The Thoughts of Chairman Mao* making up the top three all-time bestsellers.

I may not even make it into the top of the 100-million-plus-copies-sold list, currently headed by *A Tale of Two Cities* by Dickens, followed by a couple of bits of juvenile fluff by Tolkein.

Realistically, it's possible I cannot even achieve the mixed blessing of a place on the 'Most Abandoned Book' listings, a survey of the thousands of books left behind at 452 Travelodges. This honour falls to *Simon Cowell's Unauthorised Biography*, followed by a trilogy of Stephenie Meyer blockbusters, and a Dan Brown or two.

Perhaps I if tried very, very long sentences I could emulate the success of Victor Hugo, who created a sentence 823 words long, for *Les Misérables*. When he wrote to his publisher inquiring about their opinion of his 1,488 -page manuscript, he wrote "?". They replied "!".

Or perhaps I should simply sit facing north when I attempt to write. This was Charles Dickens' superstition, and it seems to have paid off quite well for him.

Did you ever manage to plough through 1,440 pages of Tolstoy's *War and Peace*? This is a swift afternoon read compared to Marcel Proust's *In Search of Lost Time*, with a word count of 1,200,000, stretching over 4,211 pages.

A dense book is obviously considered more weighty in every sense, but books starring very villainous villains are often people's favourites. As it's undoubtedly true that the devil has the best tunes, it could be hard to top Satan, in Milton's *Paradise Lost*.

Memorable baddies haunt you from childhood, and I truly disliked Cruella de Vil from *One Hundred and One Dalmatians* by Dodie Smith, and would have been terrified by Voldemort if I had read *Harry Potter* as a youth.

My generation's idea of a nasty bit of work was Pinkie Brown, Graham Greene's malevolent invention from *Brighton Rock*, and Kurtz from Conrad's *Heart of Darkness* gave me the creeps, even before Marlon Brando brought him to life in *Apocalypse Now*.

Again, I found Hannibal Lecter quite disagreeable, until Anthony Hopkins made him so charismatic and compelling. 'Manderley's' malicious housekeeper in Daphne du Maurier's *Rebecca* – and Bill Sikes, tormentor of Oliver Twist, were both more conspicuous than the leads in either book.

I have to admit to night terrors about O'Brien from George Orwell's *Nineteen Eighty Four*, which I read alongside Enid Blyton in some cruel childhood mix-up.

So whether it's Shere Khan from Rudyard Kipling; Helen Grayle from Raymond Chandler; Moriarty; Long John Silver; Grendel's mother from *Beowulf*; Quilty from Nabokov; Ferdinand from the *Duchess of Malfi* or Samuel Whiskers from Beatrix Potter; memorable baddies haunt us for far

longer than more gallant heroes.

Do you have a collection of your favourite opening lines from your most treasured books? I memorized a few:

"Happy families are all alike; every unhappy family is unhappy in its own way."

You're not going to stop reading after that opener from Leo Tolstoy's *Anna Karenina*.

Or: "It was a bright cold day in April, and the clocks were striking thirteen," from George Orwell's *Nineteen Eighty Four*.

I was pretty rattled by Kafka's introduction to *Metamorphosis:* "As Gregor Samsa awoke one morning from uneasy dreams he found himself transformed in his bed into a monstrous vermin."

But at the top of my list is the lengthy, but powerful-enough-to-want-to-memorize first words of Robert Grave's *I, Claudius*: "I, Tiberius Claudius Drusus Nero Germanicus This-that-and-the-other (for I shall not trouble you yet with all my titles) who was once, and not so long ago either, known to my friends and relatives and associates as 'Claudius the Idiot', or 'That Claudius', or 'Claudius the Stammerer', or 'Clau-Clau-Claudius' or at best as 'Poor Uncle Claudius', am now about to write this strange history of my life; starting from my earliest childhood and continuing year by year until I reach the fateful point of change where, some eight years ago, at the age of fifty-one, I suddenly found myself caught in what I may call the 'golden predicament' from which I have never since become disentangled".

I would be prepared to stand facing north throughout my remaining years, writing erect on aching bony legs, in order to compose an opening sentence comparable to that.

Universally acknowledged as the worst ever opening line, and winner of a literary award for that achievement was the opening of *Paul Clifford* by Edward Bulwer-Lytton.

"It was a dark and stormy night; the rain fell in torrents – except at

occasional intervals, when it was checked by a violent gust of wind which swept up the streets (for it is in London that our scene lies), rattling along the housetops, and fiercely agitating the scanty flame of the lamps that struggled against the darkness."

It is a testimony to the enduring patience of his readers that they read on any further.

Please don't complain to the publishers of this book to point out that my writing is even worse.

1st Baron Lytton was an immensely popular author
with a stream of bestselling novels. He coined several
phrases that would become commonplace, especially
"the great unwashed", "pursuit of the almighty
dollar", "the pen is mightier than the sword", as well
as his famous opening line "It was a dark and stormy
night" that features on many lists of worst literary
first paragraphs.

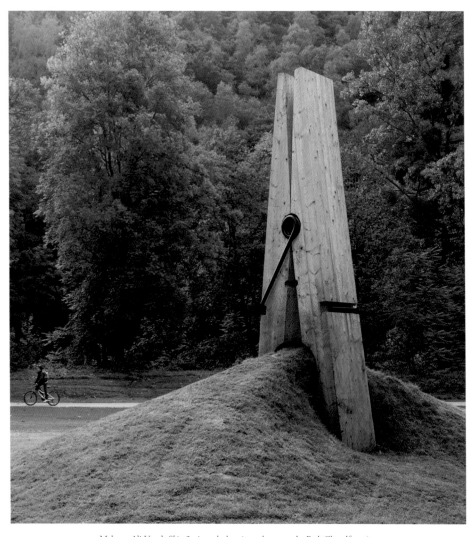

Mehmet Ali Uysal, *Skin 2*, giant clothespin sculpture at the Park Chaudfontaine
near Liège, Belgium

Mehmet Ali Uysal is an artist and teacher who installed a gigantic clothespin into the
ground near the town of Liège, Belgium. The clothespin was installed for the Festival of Five
Seasons, an arts event featuring massive outdoor installations. In this piece, the artist plays
with scale and the environment, creating this work for its specific location.

Is shopping for shoes a giant problem?

Robert Wadlow is reputed to be the tallest man to have lived at 8ft 11in. As his father was a mere 5ft 11in and his mother 5ft 7in, his gigantism was attributed to a tumour on the pituitary gland of the brain.

He only survived from 1918 to 1940, and still holds the record of the world's largest feet at 18.5in long. A Moroccan is the current champion at 8ft 1in tall, with feet achieving a matching grandeur with a 15in length. A European size 58, shoes at this scale are not available even in specialist High & Mighty stores, and require to be expensively hand-made.

Very large men may feel their specialized ancestry dates back to the Neolithic period, after a scientist discovered a human skeleton in 1890; the bones, found in a Bronze Age burial tumulus, indicated that the owner would have stood 11ft 6in, becoming known as the Giant of Castelnau, site of the anthropologists' discovery in France.

Of course, the bones were examined by Professors of Zoology, of Anthropology, and of Anatomy, all of whom concluded that they represented a 'very tall race' after the discovery of the bones of other human giants at a prehistoric cemetery 5km away from Castelnau.

With skulls ranging from 28 to 32in in circumference, and bones of immense proportions, it was believed that they belonged to men between 10 and 15ft in height.

Exceptionally tall men have always had useful careers in movies, from Andre the charming giant in *The Princess Bride*, to Richard Kiel, a nemesis of James Bond in a couple of his box office successes.

There was even a well-paid, if not always entirely voluntary post to be had in Prussian King Friedrich Wilhelm's highly feared Potsdam Giants regiment.

Claes Oldenburg came to attention as a pioneering Pop artist in the early 1960s, creating enormous, oversized versions of everyday objects – a wall plug, an ice cream, a gardening trowel, a lipstick, a typewriter eraser. On the previous page, a whimsical homage to Oldenburg's giant clothes-pin was created for a Belgian sculpture festival, nipping into a grassy knoll.

I cannot recall whether the first giant I was fascinated by was Goliath, who provided us with a proper story in one of the rare lessons I attended of Religious Instruction at school – or whether it was the unnamed gruesome Giant who chanted "Fee-Fie-Fo-Fum! I smell the blood of an Englishman!" in *Jack and the Beanstalk*.

The Beanstalk reaching into the heavens is obviously still a gripping fantasy, because both Disney and Warner Bros. found themselves planning to create a film of the fairy tale this year. Warner Bros. won the day, and called in Bryan Singer, a first-rate director, to create *Jack the Giant Killer* as a 2013 blockbuster.

Gulliver's Travels, written by the Irish clergyman Jonathan Swift was one of the first truly enthralling page-turners I enjoyed as a child – and it reads even better when you have grown up a bit. There has never been a decent film of *Gulliver*, and perhaps Bryan Singer could get round to that after *Jack the Giant Killer* sets off a wave of Hollywood summer hits of *Grimms' Fairy Tales*.

Are giants simply more captivating than the rest of us?

Didn't you prefer Little John's manly dignity to Robin Hood's rather fey character in green tights? And show me a red-blooded girl who didn't find Hagrid far more appealing than soppy little Harry Potter.

In truth, wouldn't it be worth having to get your shoes hand-made to live your life as a majestic 7-footer?

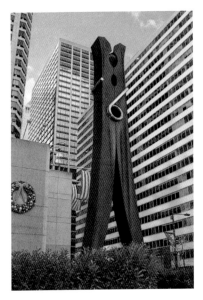

Claes Oldenburg, Clothespin, 1976, steel, 45ft high

Clothespin is a weathering steel sculpture, located at
Centre Square, Philadelphia, where it's been since
1976. "Clothespins have an architectural character,
like the three-way plugs which also lie about my
studio. The *Clothespin* is intended to relate to the
skyscrapers around it, and especially to the soaring
freestanding tower of the City Hall," says the artist.

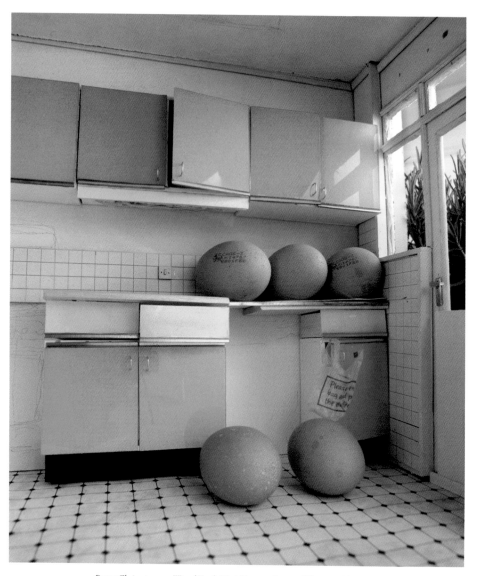

Petros Chrisostomou, *Wasted Youth* (25 Ashbourne Avenue, Whetstone N20 0AL), 2008,
colour photograph, 150 x 120 cm

"Chrisostomou photographs small-scale, ordinary, ephemeral objects in architectural models that he
constructs himself, and then dramatically arranges, often employing lighting and staging
conventions of the theatre. The illusionary effect he achieves highlights the artist's playful approach,
which fluctuates between mimicry of the real world and construction of a surrealistic reality."

Tina Pandi, Curator, National Museum of Contemporary Art, Athens

Have you ever eaten a delicious duck foetus?

Neither have I.

Balut is a fertilized duck egg with a nearly-developed embryo inside that is boiled and eaten in the shell. It is considered a delicacy throughout Asia, especially the Philippines, Cambodia, and Vietnam.

Balut are offered by street vendors and besides being regarded as a high protein hearty snack, they are popularly believed to be an aphrodisiac.

Gourmets find them most flavourful after they are at least eighteen days old – the egg providing three chewy bites that might include the head, wings and forming skeleton, perhaps with a few feathers.

If Balut doesn't appeal to your own refined taste buds, you might try the chicken testicle soup, also readily available. The testicles are creamy on the inside and very soft, similar to tofu, but with a sausage-like skin. They come in a choice of black and white and taste like undercooked egg with a custard consistency. Again, the bonus for consumers is that they supposedly provide extra stamina for men, and glowing skin for women.

In China you could try the Pidan, or Century Egg, made by preserving chicken or quail eggs in a mixture of clay, ash, salt and lime, for several months.

During the process, the yolk turns a dark greeny grey, with a smooth texture, and an aroma of sulphur and ammonia, while the egg white becomes a dark brown, translucent jelly.

As an hors d'oeuvre, the Cantonese enjoy the egg with slices of pickled ginger root sold on a stick. In Taiwan, Century Eggs are popular served on a bed of cold tofu, with a drizzling of light soy sauce and sesame oil.

Century Eggs are also prized at special events such as wedding banquets or important birthday parties.

I have an answer for you if you have always puzzled about which came first – the chicken, or the egg. Scientists have discovered that the formation of egg cells relies on a protein found only in a chicken's ovaries. They have therefore deduced that an egg can only exist if it has been inside a chicken.

A supercomputer called HECToR based in Edinburgh was used by researchers to zoom in on the development of an egg. If you'd like to read more on this fascinating topic, the discovery was revealed in the paper *Structural Control Of Crystal Nuclei By An Egg Shell Protein*.

Just so you are completely clear on what keeps our academics busy, Professor Freeman from Sheffield University's Department of Engineering Materials was delighted to report: "It has long been suspected that the egg came first, but now we have scientific proof that demonstrates that in fact the chicken came first."

Once again, Mother Nature has shown herself to be more advanced intellectually than our world's leading scientists.

I have a handy check-list of little known chicken facts for you.

Did you know that there are more chickens on earth than there are humans? Or that the greatest number of yolks ever found inside a single chicken egg was nine? Or that the chicken is the closest living relative of the Tyrannosaurus Rex?

Did you know that chickens can cross breed with turkeys? The result is a Turken.

Or that some chickens can fly, with the longest recorded distance achieved of 301.5 feet? If you are ever hit on the head by a falling egg, you may have found yourself under the flight path of a flying fowl.

The highest price ever paid for an egg was £8.9 million.

It sold in November 2007 at Christie's auction house. The buyer was a Russian, not an oligarch, but the director of the Russian National Museum.

It was one of the few Fabergé eggs that didn't belong to the Russian

Imperial family and had been owned by the Rothschilds since 1905.

Upon the hour, a diamond-set cockerel pops up from the top of the egg, flaps its wings four times, nods his head three times, crowing throughout the procedure, which lasts for 15 seconds, before the clock strikes the hour on a bell.

Personally I prefer my eggs from Waitrose, poached for about four minutes.

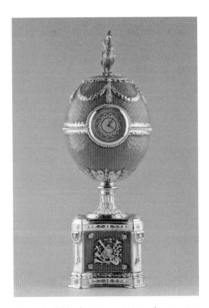

The Rothschild Fabergé egg, 1902, set three auction records at £8.9 million: it was the most expensive timepiece, and the highest price achieved for a Russian object, and surpassed any previous price paid for a Fabergé creation.

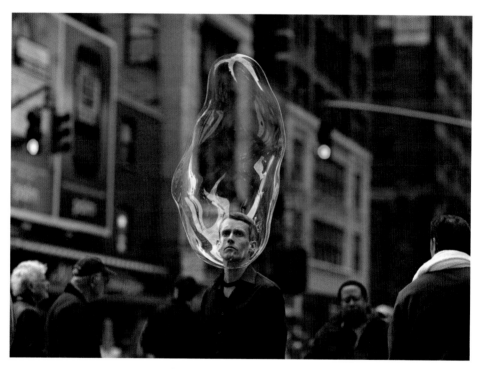

Romain Laurent, *Something Real*, 2010

Shot in New York, French photographer Romain Laurent's series of photographs entitled *Something Real*, shows an ordinary man, wandering through the streets of the city with a large bubble around his head. Suddenly the bubble is broken. Laurent explains: "It's a feeling. It illustrates a moment in someone's life, when this person feels disconnected from the reality while being part of it, and suddenly wakes up. It is something undefined, a feeling that is hardly touchable or noticed by himself or others. It's not sad or happy, it's floating in between, it's almost normal but slightly weird. But it is 'Something Real'."

Every bubble bursts and leaves a fool bust.

The Benedictine monk Dom Perignon is often credited with inventing champagne, though he personally considered that as far as wine was concerned, bubbles were only fit for the corrupt, the immoral, the damned.

Created accidentally, it was called 'Devil's Wine' as bottles exploded and corks blew out. It wasn't until the 19th century when the 'méthode champenoise' made the wine more stable, that its popularity exploded even more dramatically than the early bottles.

Champagne went from a production of 300,000 bottles a year in 1800 to 20 million bottles in 1850, as entrepreneurs and speculators rushed into the market, creating many brands still popular today.

But unlike many bubble investments over the decades, champagne continued to flourish.

At much the same time as France was fiddling with fermentation, in Britain the economy was beleaguered by the long war of the Spanish Succession we had become embroiled in. The Chancellor of the Exchequer in 1711, Robert Healey, had a scheme that he believed could, at a stroke, help cut the national debt, and put an end to the costly and unpopular war with Spain. He created a new joint stock company which would be granted a monopoly trade with Spain's colonies in the West Indies and South America – and his South Sea Company was going to kill two birds with one stone.

The Government convinced investors that by harnessing the potential of this previously untapped market, delightful returns would accrue to its shareholders. It was a triumph of propaganda, overcoming all prevailing evidence; the share price flew as the company kept up its bullish predictions, issuing more and more stock, while prices rapidly increased ten fold in six months.

Success demanded they kept up the charade of great profits to come, but instead the South Sea Company bubble ruptured overnight, leaving thousands upon thousands of investors declared bankrupt.

This was an optimistic age, with many new opportunities to be grasped, and elsewhere in Europe, the Dutch were still reeling from their own bubble crisis.

The tulip is nowadays a ubiquitous sort of bloom, availiable by the bundle in supermarket flower bins. This wasn't always the case. Tulip bulbs were first introduced to the Netherlands when a botanist began to cultivate the flower with great acclaim in the 17th century. Soon in Holland tulips became a must-have item, the equivalent of a couture gown or a fashionable artwork; owning tulips became a conspicuous sign of your wealth and status.

Trade in the bulbs flourished and as common strands of the flower became more widely available, demand for newer varieties intensified; even as the tulip became more prevalent, prices escalated rather than lowered.

At the peak of the craze, dubbed Tulip Mania, traders were earning great fortunes, and the Dutch, renowned for rational behaviour, seemed to be suffering from a mass disappearance of common sense. The rarer, exotic

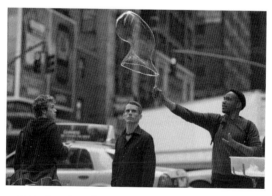

During the making of *Something Real*, 2010 in Manhattan, a photo assistant had a large loop which he put in soap water and then placed over the model's head to create a real bubble.

bulbs were selling for ten times the annual income of a skilled craftsman.

Apparently, the bulbs were often put on display – deemed too precious to be planted in the earth – better to be fondled and admired.

Then, as if a spell had been lifted, this collective fantasy vanished abruptly when an auction in Haarlem failed to attract any buyers. The frenzied atmosphere, the scrabble for prize lots, simply failed to materialise.

The market collapsed that very day, as did any certainty in 'intrinsic value'. One would think that we are familiar enough with stock markets failing, real estate bubbles evaporating, to all feel wiser now. But sadly, the financial turmoil currently sweeping so much of the world can still be traced back to greed and vanity overcoming sanity.

And as you know, the dot-com bubble is far from over. When the internet began to enmesh itself in our lives and emerge as a global marketplace, online companies began to proliferate on the promise of wonderful rewards for comparatively little investment. But as the theory 'get large or get lost' took hold, more and more investment was required to keep your technology ahead of a rapidly evolving group of competitors.

Essentially, out of the billions invested in all kinds of start-ups, only a few saw a return on their money. For every Amazon there were hundreds of Flooz.coms; this particular short-lived organisation ended up pouring $50 million in financial backing down a drain.

And yet, champagne seems to be immune, its bubbles still a siren call to optimism and light-headedness. It is an irony that the Benedictine Dom's unloved creation now attracts Tulip Mania extravagance.

Two hundred bottles of 1907 Heidsieck were recently discovered perfectly preserved in a shipwreck in the Gulf of Finland. The freighter had been on its way to deliver its precious cargo to the Imperial Court of Tzar Nicholas of Russia during World War I, when it was sunk by the German fleet.

The bottles were retrieved and a single one sold at auction, to a wealthy Russian obviously, for $275,000. Bubblicious indeed.

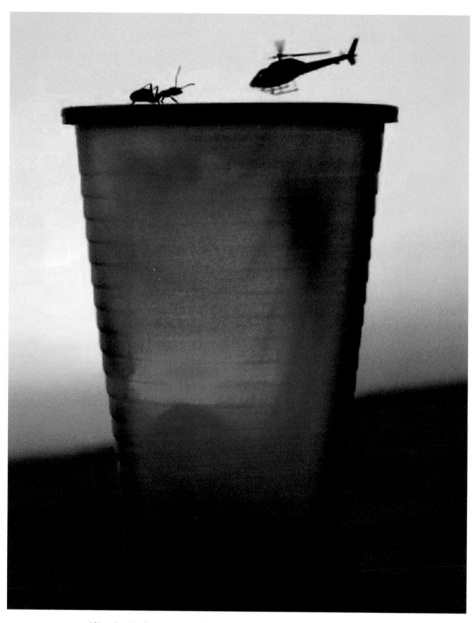

If Jonathan Swift were an artist living in the 21st century he might have created this
Lilliputian scene where people are the smallest creatures on a planet dominated by mass-
produced items. Here man sits in his tiny helicopter going into battle with a giant bug – but
the king of them all is a plastic cup.

Ants shall inherit what's left of the Earth.

Ants are better than you and me.

They make finer citizens of the planet, placing group interests above their own.

They have bigger brains in proportion to their size than we do, better sense of smell than a dog, and can lift fifty times their body weight, not with their feet, but in their mouths.

They are provided with two stomachs, one to feed themselves, and one to feed others.

Queen ants mate only once but keep sperm viable for fifteen years, producing 300 million offspring. There are now one million ants for every human on earth, and their population is growing at a far faster rate.

But what makes them such fearsome foes for mankind is that ants are incapable of feeling contentment. They have no reason to stop invading, they feel no compassion, and they all obsessively work to one purpose, always unified, with no in-fighting, personal motivation, or internal arguments for supremacy.

An excellent example of flair for preservation, and 'Lebensraum' is the Argentinean Ant. As the name implies they are supposed to be native to Argentina, but they have been travelling to Europe on ships and planes, and across America, hitching a lift on cars and trains. They cover 500 miles of California, but in Europe one colony covers 3,700 miles, and has grown to this scale in less than 100 years.

Their loyalty is to their colony, but they are happy to join forces with other Argentinean varieties in building a super colony, that endlessly expands and assimilates.

When scientists gathered ants from across the world and put them

together, the ants recognized that they belonged to the same global megacolony by "rubbing their antennae together and sensing the chemical composition of their cuticles".

When it comes down to man vs. ant on Planet Earth, remember that they were intelligent enough to take advantage of us, latching on to our transport to expand globally.

It is also instructional to learn of the mutually beneficial arrangement ants have with aphids. Aphids produce sugar that ants like, so they protect aphids from predators in return for the sugar – their very own Mafia protection racket, their very own 'cattle' they 'milk'.

Man is also inept at eradicating Argentinean ants, who thrive on the poison sprays normally so effective on insects; in fact the poison makes them more fertile, laying more eggs.

Mankind is literally impotent, and is simply feeding the ants Viagra.

Ask yourself this question. If you had an army of billions, stretched over six continents, and had no inbuilt reasoning to stop overwhelming the planet, why would you stop?

According to *Science Magazine*, ants routinely bury and seal their colony entrance to hide from enemies, with the ants working on the outside accepting death by starvation or dehydration, the first known example of a suicidal defence that is pre-emptive.

Another example of their support system in action can be demonstrated by the electricity blackouts caused by ant swarms. When an ant colony is harmed by an electric current, alarm pheromones are sent out, and fellow ants attack the power source in wave after wave, until eventually the electric power is snuffed out.

Ants are also highly skilled farmers. Leafcutter ants harvest greenery in South American forests at an impressive rate – 20% of the area's annual growth.

Biologists are still studying how the ants, who cannot digest the cellulose in leaves, create a fungus covered in a unique bacteria, to fight off

toxins and parasites. They have been farming in this way, and creating their own pesticides for at least 50 million years.

They also run better schools than we do. Both teacher and pupil ants are the only inhabitants of Earth other than humans who are capable of "bi-directional feedback teaching" – where both the tutor and student modify their behaviour to provide guidance at a rate perfected for the pupils' abilities.

Does that sound like any school, college or university you have heard of?

Me neither.

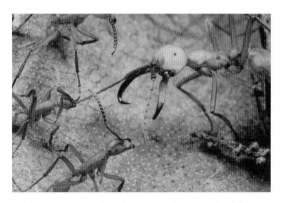

Of the 12,000 species of ant, three in particular are considered the most deadly: the Fire Ant's sting releases pheromones, attracting swarms of its colleagues to instantly attack; the Siafu Ant (seen above) travels in long columns of a million on the forest floor, with the warrior members flanking either side, jaws ready; Bullet Ants of South America are known to have the most painful sting of any insect on the planet, rated highest on the Schmidt Sting Pain Index at 4.0+.

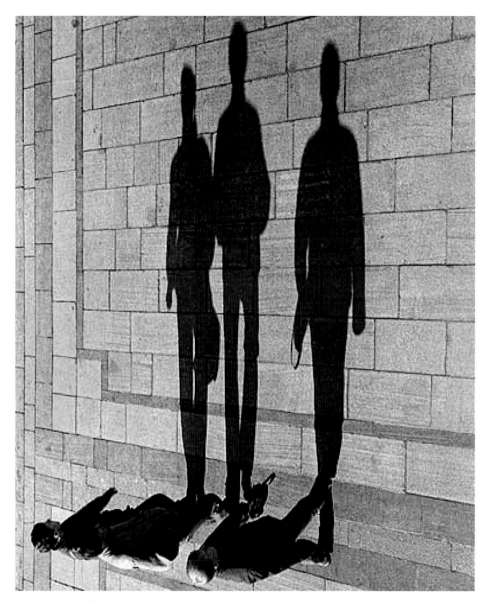

This picture is reminiscent of René Burri's photograph of a group of men strolling across a baking hot roof in São Paulo in the 1960s. But in this work by an unknown photographer the axis of the world has been swivelled by 90 degrees so that the shadows of the men are the focus of the image. We're in a scene from the movies watching a vertigo-inducing narrative about to unfold – and what's more, the three men, one of who appears to be carrying a chainsaw – are coming straight at us.

There's a shadow hanging over me.

If you grew up on *Sunset Boulevard, Double Indemnity, The Third Man, The Maltese Falcon, Touch of Evil, Citizen Kane, Notorious, The Night of the Hunter, Out of the Past, Gilda, Gun Crazy*, you know that shadow play is the defining force in film noir cinematography.

Dark city streets, a seedy office, a winding road along the ocean cliffs, a hard-boiled detective, a dangerously alluring female lead, a well-heeled villain reeking of menace, with deep focus shots, high contrast lighting, craning camera angles and an ultimately subversive plotline were the hallmarks of the classics – whether they were produced in Hollywood, or were part of the Scandinavian, French and Italian new wave.

Low key lighting so that a tilted hat hides the eyes, unbalanced composition by fragmenting light through Venetian blinds, silhouettes casting their own long shadows – all these clichés of film noir are still staples in the best of film-making today, seen in Michael Mann's *Heat*, Niels Arden Oplev's *The Girl With The Dragon Tattoo* or Søren Sveistrup's *The Killing*.

The neon lit futuristic metropolis that was the setting for Ridley Scott's *Blade Runner*, or the gloomy claustrophobia within the spacecraft Nostromo in Scott's *Alien* demonstrate again the debt that contemporary Hollywood owes to its earlier noirish masterclass in atmospheric filmmaking.

Nobody expressed that 'here is a world that is always night' better than Foster Hirsch in his great book *The Dark Side of the Screen*; he obviously enjoys a vista of shadows even more than I do.

Film noirs tend to have unusually convoluted story lines, frequently involving flashbacks and other editing techniques that disrupt and

sometimes obscure the plot sequence. First person narration by the protagonist was often a hallmark structuring device.

Crimes based on greed or jealousy, and heroes who are flawed or alienated, were primarily drawn from the literary school of muscular authors like James M. Cain (*The Postman Always Rings Twice, Double Indemnity, Mildred Pierce*) Dashiell Hammett (*The Maltese Falcon*) Raymond Chandler (*Farewell My Lovely, The Big Sleep, Strangers On A Train*) W. R. Burnett (*High Sierra, This Gun For Hire, The Asphalt Jungle*).

With its visual style, cinematographers were able to capture a tone filled with anxiety and paranoia. It can be traced back to German Expressionism, the artistic movement with its fascination for grotesque, nightmarish images painted in high contrast light and shade.

The directors who would be vital to the growth of Hollywood noir, including Billy Wilder (*Double Indemnity*), Fritz Lang (*Woman in the Window*), Otto Preminger (*Laura*) had all fled Europe on Hitler's rise to power.

It wasn't always one-way traffic. American born director Jules Dassin moved to France in the early 1950s as a result of the Hollywood communist blacklist, where he then made the classic heist movie *Rififi*.

Italian neorealism came about as World War II ended, and the films were often shot in the streets because film studios had been significantly damaged during the war. Roberto Rossellini's *Rome, Open City* from 1946 started to take cinema back to the realist writing of the early 20th century.

Vittorio de Sica's *Bicycle Thieves* used non-professional actors in harsh naturalistic lighting to detail the hardships of the working class in impoverished neighbourhoods.

Visconti, Fellini, Pasolini, Vittorio de Sica – their impact on the French new wave of Godard, Resnais and Truffaut was as great as their own French predecessors Jean Renoir and Jean Vigo had been. And they all understood the greatness of the early works of many Hollywood masters like John Ford, and Hitchcock, as did Sweden's Ingmar Bergman, who

made his own stunning contributions starting in the 1950s.

All of their influences mingled in creating the beauty of Film Noir, its bleakness, its romance, that transcended a mere 'look' employing shadows, fog, wet streets, moodiness.

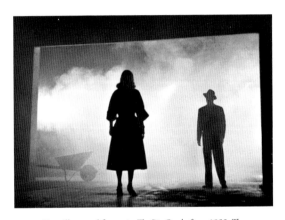

Two silhouetted figures in *The Big Combo* from 1955. The cinematographer was John Alton, the creator of many of film noir's stylized images.

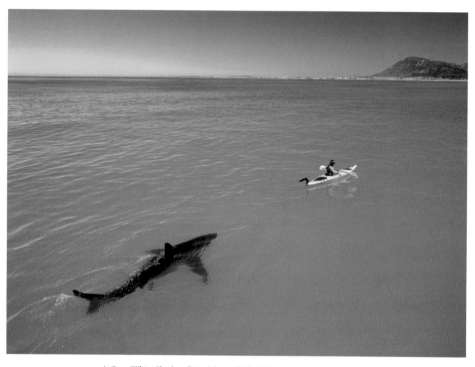

A Great White Shark stalking Marine Biologist Trey Snow, September 2005,
Africa Geographic

Photographer Thomas Peschack said: "Once we'd come to terms with having nothing between ourselves and a four-metre shark except a thin layer of plastic, our kayak made an ideal research platform for observing great white behaviour in shallow water."

We're frightened of sharks, but what are sharks afraid of?

The fear of an attack by a great white shark can be multiplied greatly by the instant panic a shark feels when confronted by the shiny sleek presence of a killer whale.

Whales have the advantage of brains, and brawn. They have worked out that sharks need to move in order to breathe, so whales begin by holding the shark upside down, immobilizing and slowly suffocating them. Then they eat the shark's liver, which occupies 30% of its body mass.

Orca whales often work as a serial killer team, using a seal they have injured as bait to attract a marauding shark. One of the whales then takes the shark to the surface, and holds it there, as its partner disembowels it to feast on the liver they so enjoy.

On Boxing Day 2011 off the Blue Cliffs beach in New Zealand, spectators on shore were able to watch as a group of killer whales herded a school of great white sharks towards the land, into shallow waters.

Whales weigh 35 times as much as a shark, but can swim twice as fast, and were able to edge the sharks closer to the beach, where they would make easy prey. Some poor sharks were seen desperately flailing onto the sand in an effort to escape the hungry whales.

This was a particularly ironic fate, as shark attacks on humans mostly take place in water less than 6ft deep.

Of course, sharks are still relative masters of the ocean and have been for 400 million years, 200 million years before the first dinosaur. They go through 30,000 teeth in a lifetime, constantly shedding and replacing them with newer ones that are always larger, so they look even more fearsome with age.

They prefer men to women and target them 90% of the time, but inside their stomachs an assortment of items have been found that they have swallowed: shoes, chairs, car tyres, the rear half of a horse, a box of nails, a torpedo, drums, bottles of wine, a Florida licence plate, jewellery, a fur coat and a full suit of armour, including helmet.

This is probably because a shark's jaw is not attached to its cranium, so it can temporarily dislocate it to jut forward and swallow large objects, with no bones in its own body to get in the way.

Killer whales and all sharks share one mortal enemy – the Japanese fisherman.

For every human killed by a shark, humans kill 1 million sharks. Shark liver oil has a ready market and each shark can contain 60 gallons of oil.

Shark cartilage is used to make fertilisers, shark skin is used to make leather, liver is used to make face cream and fuel, and fins are used to make soup.

Gruesomely, specialist fisherman will catch a shark, cut off its fins for soup, and then throw it back in the sea. The mutilated creature is unable to swim, and simply drowns.

Their longevity as a species can probably be explained by their remarkable immune system, potent enough to fight off any kind of infection or cancer; they are a constant source of study to see if their secrets can medically benefit mankind.

I greatly enjoy the guides to surviving a potential shark attack – particularly as a non-swimmer, sharks hold absolutely no fear for me.

Number one on every list is… stay calm. Sharks can smell fear, and you cannot out-swim a shark. I wonder if that little gem of guidance is helpful to anyone at all.

They also tell you that playing dead is futile. Likewise you are advised not to scream, as this will likely provoke the shark further.

And you may not want to celebrate too quickly if the shark retreats. They do this in order to swiftly sneak up on you for a more perfect bite.

You hear of brave souls who strike a hard blow to a shark's gills, eyes, or the tip of its nose.

I find it hard to imagine anyone foolhardy enough to accomplish any of these survival techniques, and who wouldn't have taken the obvious path I would have, and immediately suffered a fatal heart attack before it had clamped its 6-inch teeth into me.

My favourite shark is the one in Sydney who solved a murder.

Fishermen had caught the poor tiger shark in a line they had left in the sea overnight. The shark was feeding on the fish they had trapped, and got entangled in the line. They wrestled the furious beast to the shore with ropes, and took it to the nearby Coogee Aquarium.

After a week in captivity, the shark vomited up a human arm in front of a crowd of horrified onlookers.

The arm had a length of rope tied to its wrist, and an autopsy determined that the arm had been removed by a blade, rather than the shark's jaws. A tattoo on the arm allowed investigators to identify it as Jim Smith, a former boxer and minor criminal.

He had been a police informant and had apparently tried to blackmail the wrong people, who hired a hit-man to dispose of him. The murderer dumped his body chopped into pieces into a case at the bottom of the sea, and kept the arm as proof that the deed had been accomplished. Once it had served its purpose, the arm was discarded in the bay, anchored by a rope to something heavy.

This too-good-to-be-true buffet was snapped up by our celebrity shark as it swam by.

I know there is an analogy here somewhere – no good deed goes unpunished, or such like – but sorry to report I cannot think of it.

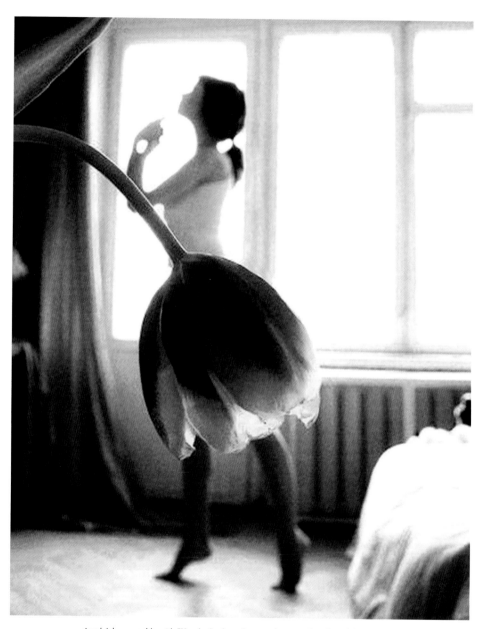

Ansel Adams notably said: "You don't take a photograph, you make it." And that's exactly
what Russian photographer Tatiana Mikhina has done with this picture. The poise of the
dancer on tiptoes is matched by the eye of the photographer, seeing that from one very
particular angle the petals of a blushy parrot tulip would form a tutu for the dancer.

Ballet is sexier than you thought.

In the early days of the Paris Opera Ballet School, managers recruited the poorest, most desperate girls to enrol for training. An example would have been 14-year-old Marie van Goethem, the model for the little bronze ballerina in her real tutu, beautifully created by Edgar Degas.

The ballet students in those days were known as the 'little rats'. And in reality, they were prostitutes in training.

They were expected to entertain the patrons of the opera, and by bringing in these unfortunate young girls, often pimped by their own parents, Paris Opera found they had opened up a wider world of benefactors.

For most of us, ballet is simply a bore. And even its practitioners know its appeal is limited – though of course not merely to people who enjoy looking at flexible girls wearing little, or men in tights and codpieces.

Though some of the tunes may indeed be hummable, I admit to never attending another ballet after a school trip to *The Nutcracker* cured me for life of wanting an encore.

In any event, I am apparently not alone in my lack of appreciation, so when Igor Stravinsky composed his *Rite of Spring* ballet in 1913, he wanted the production to be a more widely-appealing blockbuster.

He created an eerie stage set, and a ballet full of pagan rituals and sacrificial rites. For the dance itself, he opted for jerking violent movements, rather than the graceful elegance associated with ballerinas.

At the Paris premiere, after a few minutes of discordant introductory music, and early Punk dancing, the audience erupted in boos and catcalls; soon a pitched battle ensued, as the crowd hurled coins, waistcoats, hats and shoes at the orchestra and cast.

Fighting in the stalls between Stravinsky admirers and those who would have wanted him pelted on stage grew in intensity with much spitting, punching and swiping with umbrellas and opera canes.

It did the job for Igor. *Rite of Spring* played to packed houses for the rest of its run, mostly without incident, and earned Stravinsky the sort of fame composers like him can only dream of: being selected by Walt Disney as the theme music for *Fantasia*.

Ballerinas' feet are often not a sensual sight, unless you are partial to seeing widespread corns, bunions, ripped blackened nails, purple flesh, livid growths and blooded or weeping sores.

They have to plead with chiropodists not to remove thick layers of deadened callouses, since they as act as barrier to finding yourself with more blisters, between the toes.

This is the result of having feet compressed into unforgiving pointe shoes, with blocks at the ends, to heighten the effect of dancing on tiptoe. Foot ulcers are commonplace yet dancers don't take a night off – the importance of achieving status in a large corps is profound, and you cannot afford the risk of your part going to another dancer.

Some performers even employ bizarre self-medicating techniques including coating their feet in glue to keep them immovable in their ballet shoes.

Emma John noted that ballerinas were unanimous in their choice about the most harrowing ballet of them all – Swan Lake. With its relentless Pas du bourrée, running tiptoe on the spot, and with the chorus appearing in all four acts, there is no relief.

"Doing it in the round at the Albert Hall is ferocious," said one leading ballerina "because it's such a large stage to move around, smiling stoically at the audience throughout, with feet on fire. You have to sit them in ice to get your shoes back on."

The intensity of the stops mean that cramps constantly bedevil legs and feet. You're so used to a regime of intense pain, the need for a library of

painkillers is almost masochistic.

Ballerinas have danced on with broken metatarsals, an injury that would have had Wayne Rooney stretchered off a football pitch, because dancers are so used to coping with agony.

If ballet was performed by dogs, it would be banned for cruelty by the RSPCA.

Igor Stravinsky reading a musical score in a rehearsal.

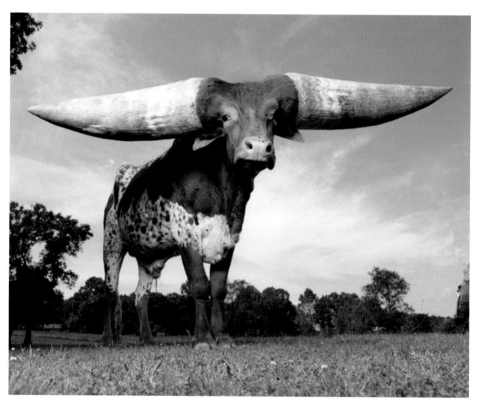

Lurch, African Watusi Steer

Lurch, who hailed from Arkansas, USA, held the 2003 Guinness World Record for largest horn circumference; weighing over 100lbs each and measuring 38 inches in circumference and 7ft, 6 inches from tip to tip in length. Lurch died in 2010 and his body was released to a local taxidermist to produce a full-sized taxidermy of the steer.

I am cowed by cows, let alone bulls.

In the summer of 2009, four people were trampled to death by cows in England over a one month period. Bovine attacks are apparently uncommon, but I dislike anything to do with the countryside, and sharing a field with a lot of very stupid 1,000lb creatures was a particularly intimidating experience I never wish to repeat.

They can't bite you, because they have no upper teeth, but being trampled must be fairly easy, and getting sandwiched between two as they clumsily bump into each other is likely to leave you more than merely winded.

Would you prefer to ride a bucking bull in a rodeo, or face a fighting bull as a matador?

Man's relationship with the bull goes back to the dusty Colosseum of ancient Rome, when under Emperor Claudius, fighting bulls provided gladiators with a brief respite from murdering each other.

In early 18th century Spain, in the sun-dappled arena of Ronda, Francisco Romero invented the modern incarnation of battling the bull by stepping down from his horse and facing up to the horns – providing his compatriots with a splendid new bastion for a Spaniard to demonstrate his masculinity.

Don't be misled by their sequined jackets and over-tight trousers; though they may well have inspired more than one Moschino catwalk show, matadoring is a brutal business.

While animal rights activists protest very crossly at this bloodiest of blood-sports, proponents of bullfighting claim it as an intricate art, combining years of training, technique and cultural heritage. They point out that the bull is a worthy adversary, suitably fearsome enough to turn

around and gore to death a gifted opponent. Ernest Hemingway, who gloried in his own manliness, immortalized his passion for bullfighting in several novels, describing it as "one of only three sports, alongside motor racing and mountain climbing... all the rest are merely games".

The spiritual and cultural home of bullfighting, Spain, is where traditionalist aficionados still stand strong, despite a steady decline in the number of fights, driven in part by a drop in municipal funding since the financial crisis and part by the steady progress of activists.

September 2011 marked a death knell for the sport when Catalonia staged their final show before a regional ban that saw ticket prices soar to eight times their face value as spectators flocked to the stadium; an indication that the move had more to do with a definitive display of regionalism against Spain's national fiesta than a sudden shift in pro-animal rights.

The spectacle itself is divided into three stages, in which three toreros each take on two young fighting bulls, with a team of six assistants who appear in the two final stages of the battle. The fight itself usually results in the bullring sand soaking up the blood as each raging beast departs this world when the matador thrusts the final *estoque* into his spine, or forehead.

Although the matadors are often horribly gored, sometimes fatally, bullfighting still creates the impression that the dice are heavily weighted in favour of man – seven against two is not an entirely balanced contest.

So Mexico, in all its wisdom, has decided the way to take the sport to the next level is through mini-matadors, who start training with cows as young as five. The headline act of the movement was Michelito Lagravere, the youngest matador in history who entertained in Mexico's main stadium, with a 48,000 capacity – the largest bullfighting ring in the world.

At the age of ten, Michelito had already killed two hundred bulls, taking on animals that were more than ten times his size, and earning up

to £335,000 per appearance.

Although the US inherited the Mexican game of charreada in the 19th century, where contestants rode bulls until they stopped bucking, Texas took the initiative to ban all forms of blood-sports (against animals) in 1891, paving the way for the modern day rodeo.

If a Spanish bullfight lasts roughly as long as an average opera, the American rodeo appeals to a more limited attention span. The length of a ride lasts only eight seconds, although if you are the cowboy clutching on to the ferocious bull, seconds tick down painfully slowly.

Both riders and their mounts are each scored out of fifty, marked on the rider's ability to maintain control and a constant, smooth rhythm, and the bull's capacity to make it as hard as possible for him to cling on with just one hand.

Described as the '*eight most dangerous seconds in sport*', rodeo riding requires thighs of steel and a good collection of chaps (leathers to cover the thighs, in case you were wondering).

The only time I saw a rodeo (never attended a bullfight – obviously too grisly, or I am too closely in touch with my feminine side) I watched in equal measure of enthrallment and bafflement as men flew through the air to violently land in dust clouds that billowed up in the late summer sun; the cowboy hats in the stadium, male and female, roared. A more picturesque display of American culture you will be hard pressed to find.

In Britain, our historic love of blood-sports overlooked these particular strands. For the Englishman, no sultry glares and prancing feet, nor chapped jeans and triumphant howls; instead we enjoyed the spectator sport of bull-baiting, popular in the last part of the 17th century.

Bulls were tethered to a radius of thirty metres while their nostrils were blown with pepper before facing a bulldog trying to latch itself on to their nose. As random as it was cruel, it was not a defining memento to British masculinity. But at least it solves the mystery of how bulldogs got their name.

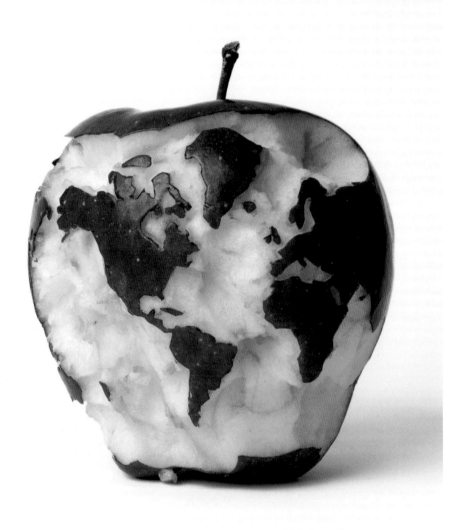

Kevin Van Aelst, *Apple Globe*, 2007, digital C-print, 40.6 x 50.8 cm

Van Aelst is a contributing photographer to the *New York Times Magazine*. In a 2005 article he explained: "It's not an intentional goal, but it's important for me that people look at my work and say, 'Anyone could have done that if they just thought of it first.' It all hinges on the idea and punch of the juxtaposition of the ordinary and the timeless. Humour is a key element."

When I hear the drumming of hooves, I don't think unicorns. I think horses.

As you probably know, Occam's Razor is the philosophical principle that urges us to select the simplest and most obvious solution, from any range of possible solutions.

We are certainly right to suspect, for example, that when we hear the clip-clopping of hooves, it's a horse, rather than a zebra.

Many philosophers before and after Occam's 14th century treatize, from Aristotle to Wittgenstein, have offered us similar guidance when we seek lucid answers, cogent logical conclusions – but find the irrefutable evidence we require is lacking.

In the present day, it is always handy to remember Occam when dealing with mulish, obstructive people: just assume incompetence, before deducing malice.

Sadly it's the case that the more wrong-headed and stubborn people are, the more likely they are to cling to batty theories, rather than simple truths.

We continue to hear pronouncements that it was Christopher Columbus who discovered that the Earth was not a flat disk, when he didn't drop off the edge of the horizon.

But in fact the flat-earth theory was generally considered bunkum in the 14th century; it had been pretty much agreed since the time of the Ancient Greeks that Pythagoras was right in proclaiming that Earth was an orb.

The oldest surviving terrestrial globe was created in Germany in 1492, but Greek astronomers were already constructing globes of the Earth in the 2nd century BC. You would need to have been something of an oddball to believe in a flat earth at the time Columbus set sail.

Of course, many of the truisms we learn are not, in fact, true.

Often, motivational speakers will try and inspire an audience by reporting that Albert Einstein was an underachiever in his early years, failing maths exams, struggling with physics, and finding himself becoming a lowly patent clerk.

In fact, Einstein was a mathematical prodigy whose parents felt school was holding him back, and provided him with advanced textbooks at the age of 12; he would likely have achieved a double first in Physics at Oxford by the time he was 14.

They still teach that Isaac Newton discovered gravity when an apple dropped on his head, as he sat in the shade under a tree on a sunny day.

In reality, Newton spent his life huddled over paperwork, calculating theory upon theory in silent, grinding, solitary work until formulating his universal laws governing the notion of gravitational bodies; he eventually had a nervous breakdown, and died years later, insane from mercury poisoning.

I don't know how Occam's philosophy would cope with the number of commonplace inhabitants of Earth that were once thought of as mythological creatures.

Sightings of a gorilla in Africa were once dismissed by scientists as nonsense, and the ravings of malaria-suffering early explorers.

It wasn't until 1847 that a physician managed to obtain some gorilla bones and a skull while in Liberia, and published the first account of the great ape.

A decade later a pioneering European explorer was the first to see a live gorilla on an expedition in equatorial Africa.

The Giant Panda was considered a myth even in China, until 1869, when a French missionary sent back the skin and remains of a specimen to scientists in Europe.

Chinese artists have depicted black bears and bamboo forests since ancient times, but never the strange panda.

The most extraordinary mythological creature to be accepted as authentic was, not surprisingly, the giraffe. But even the tiger was thought by ancient Greeks to be the legendary Manticore, said to have the tail of a scorpion with its black rings and black tipped tail.

Looking again at Kevin Van Aelst's bitten-apple globe, imagine what early cartographers would have made of that.

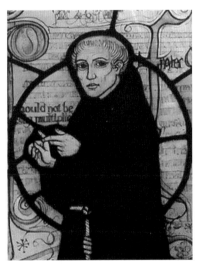

William of Ockham, from a stained glass window at
All Saints Church in Ockham, Surrey.

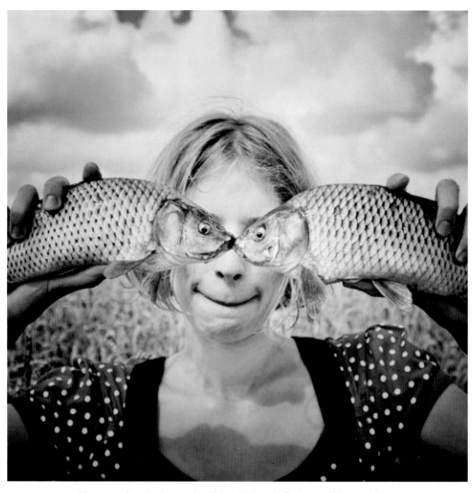

This is a visual pun by photographer Oleksandr Hnatenko for the term 'fisheye' which was coined in 1906 by American physicist and inventor, Robert W. Wood, based on how a fish would see an ultra-wide hemispherical view from beneath the water. The term was then adapted for use as a photographic lens.

Fish are enough to put you off your chips.

What's the most you would pay for a fish?

I don't imagine you would care to beat the world record of £472,125 paid in January 2012 for a Bluefin Tuna by Kiyoshi Kimura, the successful bidder from Tokyo.

Even if like him, you owned a chain of sushi restaurants, having to pay £1,700 per pound of tuna is a bit steep, despite charging very high prices and serving very small portions.

But of course the purchase did make Kimura highly respected in the sushi community, where his epithet is Tuna Titan.

Sadly for tuna, they are more prized as a Japanese treat than for being a particularly intelligent species of ocean animal.

Everyone already knows that dolphins have highly developed cognitive senses, but nobody ever told me that Sea Lions are also extremely bright.

The U.S. Navy has a Marine Mammal Programme using seals (not Navy Seals, silly) to detect mines and help recover equipment. In IQ tests they demonstrate that they have the best memory of any non-human, recalling tasks they performed many years earlier.

Octopuses can solve intricate puzzles, and distinguish between a variety of geometric shapes. They exhibit signs of play and personality, and are notorious for being troublesome aquarium inhabitants, squirting jets of water to short-out overhead lights, escaping their own tanks to break into others' to feed, then quietly returning to their own.

Sea Otters have learnt how to use tools, employing rocks to break open clams, their favourite lunch.

My favourite Lotharios of the deep are Cuttlefish; cunning experts at using deception and camouflage, they adopt female colours and form to

slip past large rivals and mate with guarded lady Cuttlefish.

I am also impressed with the Angler Fish, which dangles a fleshy lump above its head like a fisherman's lure. It can sit totally still, but wriggle its bait, which even transmits an appealing glow.

The Angler Fish is blessed with a cavernous mouth, and inward pointing teeth to gulp down and hold big fish as it enlarges its jaws and stomach.

I'm never going to go for a dip in the Amazon so I have absolutely no fear of Piranha.

In fact as I can't swim, I'm perfectly happy to look at terrifying close ups of the bacteria-coated teeth of the 12ft Moray Eel, or even scarier, its cousin the Gulper Eel, with a mouth that is slack-hinged and bigger than its body, which conveniently expands for heavy meals.

If it's really dramatically large teeth you wish to admire, the Snakehead Fish can occasionally be seen crawling on wet land, using its primitive lung for breathing air, moving from one pond or lake to another searching for a new selection of dinners.

The Fangtooth Fish has such elongated teeth that it needs a pair of sockets on either side of its head to slot them into when its mouth is closed.

All things considered, I think just sitting at a river bank fishing is beginning to sound like a hazardous Extreme Sport. And Oxford University will confirm the conclusion obvious to all aqua-phobes like me: commercial fishermen are fifty times more likely to die compared to people in other professions.

I cannot imagine the statistics for fatalities amongst scuba divers.

Did you know you could get a degree in Ichthyology? Ichthyologists are experts in marine biology and fisheries science.

Aristotle was the first to turn to fish as a formal academic study, and documented anatomical and behavioural differences between fish and marine mammals.

Generally considered to be the most influential ichthyologist, David Starr Jordan wrote 650 articles and books on the subject, as well as serving as President of Stanford University.

So if you think having your children take Media Studies as an A-Level subject is unworthy of their potential, you could always buy them a couple of Goldfish and see if that sparks their inner Aristotle.

Yumiko Utsu, *Octopus Portrait*, 2009,
C- Type print, 55 x 44.5 cm

Utsu's photography is influenced by the fantasies of
Western artists since Hieronymus Bosch,
particularly surrealists like Dalì, and – her favourite
– the Czech animator, Jan Švankmajer.

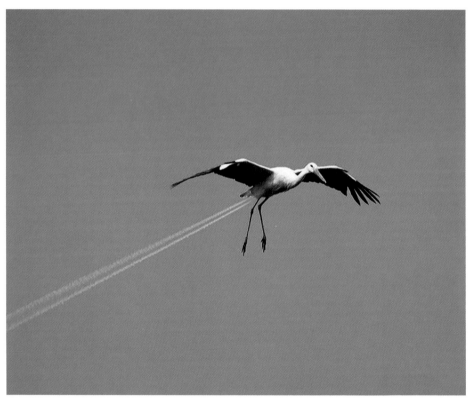

This stork appears to be leaving a vapour trail, demonstrating its high powered thermal-supercharged engine is functioning well. The Marabou stork with wings stretching 10.5ft joins the Andean Condor in having the widest wingspan of all birds. Early fossils show that storks have lived on earth for about 25 million years.

Birds sing sweetly, but kill swiftly.

About 10,000 times each year, an airplane hits a bird.

The planes can 'ingest' birds weighing up to 4lb with no significant effect, but many birds are larger. On 12th July 2012 a United Airlines plane struck a bird just as it was about to land at Denver airport. It ripped a massive hole in the aircraft's nose, but the jet was able to continue its landing, with no crew or passengers injured.

Had the large bird been struck further away from the airport, the damage inflicted on the plane could have been catastrophic.

I like birds, but not in a bird-watching sense. (And I don't, of course, approve of jokes that begin "Why are women called birds/chicks? Because they pick up worms, have bird brains, get into a flap", etc.)

My favourites birds are the very bright ones like the owl, and the very butch ones like the eagle.

The owl's distinctive pattern of round feathers on its face actually acts as a satellite dish, giving it the best directional hearing in the world. The feathers can be individually adjusted to increase reception, so that the owl can hear a mouse stepping on a twig from 75ft away. Its sound elevation skills can detect the height from which the mouse is moving below, and use its finely-serrated feathers to allow it to fly silently, and extremely slowly, until it swoops.

Less subtle, but admirable with its fearsomely graphic attack strategy is the Harpy Eagle. It has talons the size of a grizzly bear, which can exert a crushing grip of 530lbs per square inch. An average man has a grip of 60lbs, a powerful dog 300lb, a wolf 400lbs. The Harpy also has a razor sharp beak, the better to crush and eat its favourite lunch, the brains of monkeys. It is powerful enough to grab and carry away animals of its own size.

I am a signed-up member of the Ostrich Fan Club. They can run at 60mph, and keep it up for half an hour, long after other fast animals, like cheetahs, have given up.

An Ostrich may have talons on its feet of only 4 inches, but it possesses two finger claws at the end of each wing to give it extra options for attack. Its most fearsome weapons are its legs, which pack more power than two of Mike Tyson's best knockout punches, enough to kill a lion with a single kick. It won't surprise you to learn that the ostrich is a direct descendent of Tyrannosaurus Rex.

The crane, cousin of the stork you see pictured here, is the most monogamous of earth's creatures. They mate only with their single partner, once a year, no matter how long they have been together.

Passions are kept flowing by performing the intricate mating dance, the most elaborate in the animal kingdom.

The dance generally begins with a crane picking up a clump of grass, tossing it in the air, and catching it in its mouth.

They then jump, extend their wings, bow to each other, heads bobbing, and the dance will find the colony joining in with encouragement.

Please try this at home.

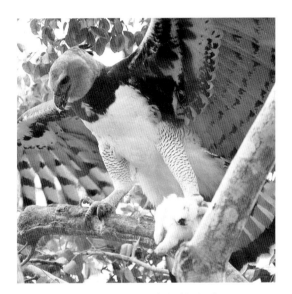

A Harpy Eagle with its fresh rabbit lunch.

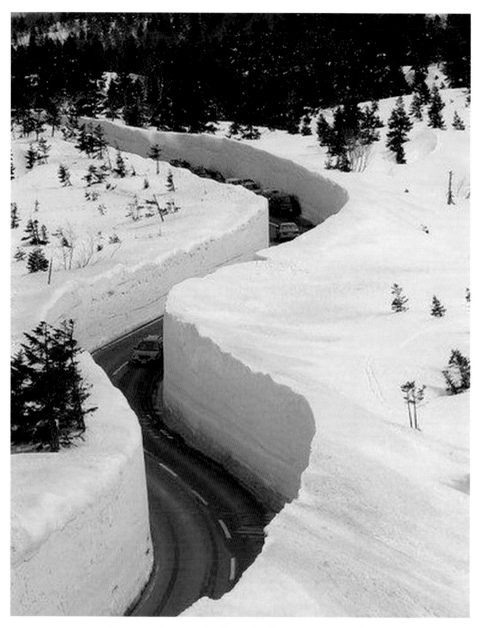

Photograph of the Corridor "Yukina-Otani", part of the Tateyama Kurobe Alpine Route, Japan.

The route opened in 1971 and traverses through the Northern Japanese Alps. Its unique snow walls line some of its roads in spring. These vast ramparts can reach up to a staggering 20 metres high.

Are we bi-polar about snow?

There's the right kind and the wrong kind.

A light dusting of it will bring British airports and public transport networks to a grinding halt. The rapid melting of a great deal of it creates much hand-wringing among climate change believers.

Children pray for enough of it to let them off school, to build snowmen and fling snowballs. Fluffy but unforgiving, silent and deathly cold, snow occupies a central place in ancient lore, military history and contemporary culture, throwing up tales of great endurance and unexplained mystery.

One of the greatest snow survival, and indeed snow slaughter stories, is Hannibal's famous crossing of the Alps. One of the most formidable Generals in history, and a brilliant strategist, Hannibal decided to attack the dominant Roman Empire via a short cut through the Alps – an unprecedented act.

He added to the exoticism of the attempt by deciding to march elephants through the peaks and troughs of the Alpine range. Beset by food shortages, attacks from barbarians hurling rocks at his army at every pass, the troops themselves were not ideally prepared. Recruited from some of the hottest places on earth, a Numidian cavalry is not trained for snow and ice.

Hannibal drove his men through hazardous conditions into the Po valley, where he went on to launch one of the most unanticipated invasions of Italian soil ever executed.

Of course he failed to defeat the Roman Empire, after a rather unfortunate misadventure with a walking cane en route. Hannibal was trying to persuade his army of the solidity of a snowdrift by sticking his

cane into it. The cane managed to dislodge an entire shelf of snow, killing 18,000 of his 38,000 men, 2,000 of his 8,000 horses, not to mention many of his elephants.

Figurative representations of snow across all cultures seem to operate along a severe gender bias. Jack Frost, removed from his Viking origins, has become a loveable imp, craftily decorating the windows of wintery homes across the U.S. and Britain, nipping at noses and fingers not sufficiently wrapped up.

Raymond Briggs' *The Snowman* is one of the more famous contemporary representations of wintery masculinity. An excellent dancer and motorcyclist, not to mention possessing the ability to fly long distances, he stole many a young child's heart with his Christmas adventures.

As in all children's Fairy Tales the story turns dark however, in a cruel but inevitable turn of fate The Snowman is discovered melted the next day. For the sheer number of little hearts broken in one summary execution, writer Briggs must stand high on the league table of snow sadists – rather like Hannibal.

Women have come off considerably worse in this genre. Representations of icy females plumb the depths of evil. In Japan Yuki-onna stalks through the pages of classical literature and modern Manga stories.

Translating variously as 'snow-harlot', 'snow-hag' or 'snow-wench', she hovers over the snow's surface, clothed in white or naked, black hair hanging to her waist, skin almost transparent. She uses her sexual partners to increase her life force, and then turns them to ice.

The White Witch, who inhabited the immensely popular Narnia series, was clearly inspired by Hans Christian Andersen's story of the Snow Queen.

The White Witch, or Jadis, originally hailed from an alternate world called Charn. The progeny of a series of entropic line of kings and queens,

the last worse than the one before, she locked herself in battle for the land with her sister, whose triumph she avoided by uttering 'The Deplorable Word' which wiped out Charn.

Expelled from the world she destroyed, she lay around in a pond until arriving at Narnia to be finally vanquished by Aslan. I've never read C.S. Lewis' classic, and just learning this little about it has ensured I never will.

Snow is also the setting for some of the more bizarre stories of paranormal activity and cryptozoology – just a Greco-Latinate name for the kind of people who hunt for the Loch Ness monster.

The Dyatlov Pass incident involved a group of young men and women who set out for some long distance cross-country skiing in Russia. Six days into their trek they ran into heavy weather, and decided to camp on the mountainside to shelter from the incoming snowstorm.

Eerily this is documented in photographs printed from film found in cameras at the discovered campsite. After they failed to appear on their expected return date the families of the hikers raised the alarm.

Extensive search parties eventually uncovered the remains of the tent, lines of footprints made by humans wearing no shoes, and three corpses whose positions seemed to suggest they had died trying to return to the tent.

After further searches lasting four months, the other bodies were found. These later cadavers bore signs of heavy trauma, such as those inflicted in a severe car crash, and in a further grisly detail one woman was missing her tongue.

But why was the tent ripped open from the inside? Why had all the men and women left without shoes? What had caused the severe trauma to some of the bodies? Why did they all test very highly for radioactivity?

It's been a field day for conspiracy theorists about the then Soviet government.

The snowy wastes and peaks of Tibet play host to one of the world's most hunted mythical beasts. Variously named the Yeti or Abominable

Snowman, this long limbed, hairy, giant ape-man has apparently been sighted by a number of mountain explorers.

He has only ever been captured in highly pixellated 'tree hiding' activity, and is known for leaving liberal numbers of giant footprints behind in the snow.

Many mountaineer accounts include tales of woeful howls in the night, but have been dismissed as the sounds of the rather terrifying local wildlife such as the Langur monkey or Tibetan blue bear.

To bring you up to date, cryptozoologists today are gripped by newer concerns – the Bunyip, the Kraken and the Lizard People. May we wish them good hunting.

Tourists and traffic make their way through the imposing walls of the
Tateyama Kurobe Alpine Route, Japan.

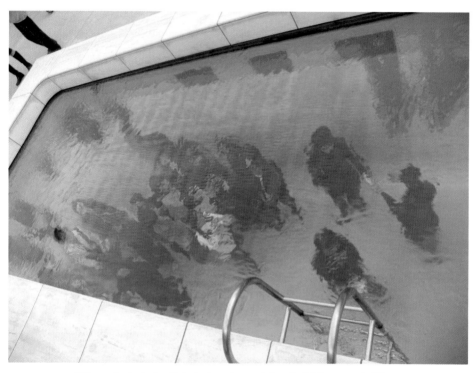

This very disorienting installation by Argentinean artist Leandro Erlich consists of a full-size pool in which people can be seen below the water line fully clothed and breathing. The visual trick lies in the fact that there is a concealed entrance to the pool which is in fact empty, covered by a large, continuous piece of acrylic which suspends water above it. Swimming Pool was first conceived in 1998 while the artist was in residence in Houston as part of the Core programme. Since then, it was featured at the Venice Biennale and has found a home as part of the permanent collection at the 21st Century Museum of Contemporary Art in Kanazawa, Japan.

Swimming in blood.

Do you prefer a dip in the sea or a swimming pool?

If you can make it to Chile, you get as close as you ever will to enjoying the best of both.

The San Alfonso del Mar resort is home to a swimming pool that is the length of twenty Olympic-size pools, with its deep end needing a dive of 115ft deep to touch the bottom.

An advanced computer controlled suction and filtration system keeps the sea water at 26°C year round, rather like swimming in your own personal 3,323 sq ft lagoon. It took five years and one billion dollars to build.

The entire length of the swimming pool runs alongside a glorious beach, but the pool is so large that another beach was artificially created around the rest of it, so you could step onto golden sand whatever side of the pool you wished to emerge.

If you like unusual swimming pool experiences, you might enjoy the Joule Hotel pool in Dallas, Texas. Ten storeys above the ground, the pool projects out over the edge of the building, hanging directly above the main street. It gives swimmers without vertigo a dazzling city view.

The 'Ocean Dome' in Japan is the world's largest indoor swimming pool, 300 metres long and 100 metres wide, with a domed roof painted sky blue, and a few fluffy clouds.

The temperature inside the pavilion is kept at 30°C and the pool contains a highly effective artificial wave machine, with a faux giant volcano at one end of the dome.

In Thailand's Koh Samui, a boutique hotel called 'The Library' offers you the macabre experience of swimming in their blood-red beachside

pool, with red umbrellas and red loungers to complete the Martian atmosphere.

If you are very gregarious, you might enjoy sharing China's 'Dead Sea' swimming pool, vast enough to accommodate 10,000 visitors at once. Due to the high level of salinity swimmers float on the surface, all happily crammed together, with barely room to perfect your backstroke.

My own inability to swim probably draws me to my favourite genre of cinema, the submarine movie.

Years ago I caught a film made during World War II; *We Dive at Dawn* depicted a fictional submarine HMS Tiger on a mission to destroy a fictional German battleship Brandenburg.

Fictional or not, it reportedly lifted morale in cinemas across Britain in 1943, as audiences cheered on our navy.

Another good British submarine tale was *Above us the Waves*, about Royal Navy midget submarines vs. Germany's legendary warship, Tirpitz.

Then followed *Morning Departure* about a sunken British submarine trapped on the ocean floor, and two great Hollywood films *Run Silent Run Deep*, and *The Enemy Below*. Both these classics were filled with depth charges exploding and skimming round the submarine, and the eerie ping-ping sound of sonic searches, transfixing the crew of the sub being tracked, the hunter hunted.

A Cold War movie *On the Beach*, about a submarine caught up in post-nuclear annihilation acutely captured the nervous anxiety of the time.

Of course there are more dire submarine films than good ones, but I happily see them all in case I find another *Ice Station Zebra*, or *Hunt for the Red October* or *Crimson Tide*.

But it was left to Germany to produce the greatest ever submarine epic: *Das Boot*.

For most of its 293 minutes, you entered the visceral, clammy atmosphere of a World War II German U-boat, sharing the boredom, filth, blood and sheer terror of weeks above and below the waves.

If you are as nervous about getting into the sea as I am, or you get as claustrophobic as I do inside the shower, this is one film I certainly promise will get your heart racing.

Life has been far from incident free for submariners, even in peacetime.

In August 2000 a Russian submarine carrying cruise missiles was in the Barents Sea when a leak of hydrogen peroxide in the forward torpedo room detonated a warhead, triggering a blast of half a dozen more, in an explosion that could be read on seismographs across Northern Europe.

The majority of the 118 crew died in an instant, but miraculously 23 survived in the stern of the sub; despite an international rescue effort, they all perished several days later from suffocation as oxygen ran out.

The Russian Navy was roundly criticized in its home country by family members of the deceased seamen for failure to accept international help in a timely manner, put down to secrecy considerations.

A U.S. submarine collided with a Japanese fisheries training ship, and there have been numerous other collisions, floodings, fires, subs running aground, and subs sinking following mechanical malfunctions; they have involved the vessels of China, France, Canada and Australia, but more widely reported are accidents involving the U.S., U.K., and Russian fleets.

It takes a brave man indeed, and certainly one more psychologically balanced than me to cope with being enclosed in a steel prison, willingly spending weeks at a time without glimpsing daylight, or breathing fresh air, crammed into extremely limited space, in the starkest of surroundings.

Submarines, however, are the most lethal weapons on the planet, and the thought of a nuclear sub parked somewhere off your waters must have kept many an insane despot in check over the years.

The sound that is never heard on today's most powerful submarines are the words 'Up Periscope'.

Their command rooms look like the deck of the *Starship Enterprise*, flanked by a multitude of digital screens capable of displaying any view you require; directly fed from orbiting satellites, or by drones flying

directly over an area of specific interest, the immense nuclear boat bristles with an arsenal of weaponry, much still classified.

Its supercomputer packs hundreds of tetrabytes of processing power instantly able to investigate any anomaly.

You really wouldn't want one of these Virginia-class vessels falling into the wrong hands.

Their shielding devices make them invisible to counter-attack, enabling any committed psychopath to control the world, while hidden somewhere under the sea.

Doesn't that sound like a promising screenplay? If only I possessed the wit to write it.

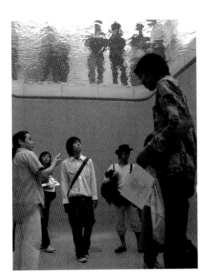

The view from below: visitors to the 21st Century
Museum of Contemporary Art in Kanazawa, Japan
stare up from the bottom of the pool to the
disbelieving spectators at the top.

Dancing Tree, Vernon, British Columbia, 2007

Amateur photographer Carol Lynn Fraser says this of her image of the dancing tree: "I take little credit for taking the photo of 'Dancing Tree' as it was divine providence that literally took me by the hand and led me to her. It was a gift that I now graciously accept. Once in a while someone suggests it is a fake photo... to which I politely respond that 'it is not', nor was it ever photoshopped. The simple little tree was truly that beautiful."

Do only phoney photographers photograph with their phones?

The 2004 Indian Ocean tsunami was the first global news event where the majority of the first day news footage was no longer provided by professional news crews, but rather by Citizen Journalists, using camera phones.

Camera phone video and photographs taken in the immediate aftermath of the 7th July 2005 London bombings were featured worldwide, on global TV channels.

On 30th December 2006, the hanging of former Iraqi dictator Saddam Hussein was recorded by a video camera phone, and made widely available on the Internet. The guard responsible was arrested a few days later.

Most photographs today are taken on Smartphones rather than cameras. Besides shredding the camera industry, the Smartphone is replacing watches, alarm clocks and laptops; they are also replacing books, via EBooks, and game consoles. Even TV and movie watching on your phone is becoming commonplace. People use their phones to film and photograph more than they do to talk.

There used to be the perception that you can only take a 'proper' photograph with a 'proper' camera. No longer.

Not only does the quality of the camera on leading Smartphones enable you to take pictures sharp enough for high resolution reproduction, but with Zeiss lenses and 16 megapixels becoming the standard, their qualifications match most stand-alone digital cameras.

And of course on your Smartphone, you can transmit your picture globally in seconds, creating our new world of Citizen Journalism. (I say *you* can transmit, because I am too befuddled to use anything but an elderly Nokia, no functions to frustrate and embarrass me – it simply

makes and receives calls.)

According to Jay Rosen, Professor of Journalism at New York University, citizen journalists are "the people formerly known as the audience, who were on the receiving end of a media system that ran one way, in a broadcasting pattern, with high entry fees and a few firms competing to speak very loudly while the rest of the population listened in isolation from one another; but today the people formerly known as the audience are simply the public made realer, less fictional, more able, less predictable."

Writer Theresa Malone pointed out, "We're all Cartier-Bressons now – but would he have used a cameraphone himself? He famously employed a Leica because it was small and, importantly, quiet – he liked to be as unobtrusive as possible when photographing street scenes." But today we're so accustomed to people taking photographs all around us that he could be as inconspicuous as he wished.

With Smartphone images, you are able to employ the resources of a full photographic lab to manipulate your photos simply and instantly.

Facebook recently paid $1 billion to buy the Instagram app, that enables Smartphones to take advantage of mood and tone filters, with adjustable depths of focus, and allow its 80 million users to greatly enhance their pictures to a professional level.

Customers who go on to share their phone images include Barack Obama, Justin Bieber, Oprah Winfrey, and Jamie Oliver, all with millions of followers.

I too would like to have millions of followers admiring my photographic skills, so I asked my daughter if I could borrow her phone, and try my hand at becoming a citizen journalist. I must be the only person left alive who still moans "my pictures didn't come out".

I'm clearly not smart enough to master a Smartphone – even one, apparently, that only a fool could fail with.

The Crooked Forest, Gryfino, photographed by Maciej Sokolowski,
north-west Poland

Planted around 1930, there are about 400 of these curved pines near a
larger forest of straight growing trees in Gryfino. They were allowed to
grow freely for about ten years, before being held down in what is
thought to have been some kind of human intervention. Speculation as
to what the trees may have been intended for ranges from use in making
bent-wood furniture, the ribs for boat hulls or yokes for ox-drawn
ploughs.

A Volkswagen Polo is loaded into the car towers of the VW Autostadt in Wolfsburg, Germany.

The Autostadt (German for Car City), situated next to Volkswagen's HQ, is the company's theme park and distribution centre where 5,500 visitors a day view Volkswagen brands including Bentley, Audi and Lamborghini.

You are simply a soft, ripe target.

Do you drive a car? Then you are somebody's cash cow.

Last year drivers paid £1.3 billion in parking charges at council car parks. I wonder if this is a major contribution to the decline of our High Streets, with one third of shops empty in some parts of Britain.

Councils make a further £1 billion a year from parking fines.

Of course this figure would be drastically reduced if more people appealed against their parking ticket; campaigners claim that many fines are invalid, and that 68% of drivers who took their case to an independent adjudicator actually won their appeal.

Frequently referred to as a stealth tax on motorists, targeted as sitting ducks who simply sigh and pay, it has become the most lucrative way for councils to make money.

But of course battling to overturn a parking ticket isn't without pitfalls.

A Toronto doctor lost her epic fight against a $31 fine for parking in a spot near the hospital she worked in, during a blizzard in November 2007. She pushed $3 into the meter, but the machine failed to print the receipt that is supposed to be placed on the car dashboard as proof of payment. She tried again at another machine, with the same result. When she returned an hour later, a parking ticket was stuck to her windscreen.

She theorized that there may be an inherent defect in the machines in such weather, and consulted an analyst who agreed that condensation forms inside the meters when the temperature fluctuates rapidly, which can affect their efficiency.

She decided to launch a class-action lawsuit on behalf of aggrieved motorists who shared her experience, with the aim of gaining access to the pay-and-display machines for expert study.

After a number of hearings, the case was dismissed when it finally arrived at the Ontario Supreme Court.

Justice Perell explained his ruling, which landed the doctor with an extra $70,000 bill to cover the city's legal costs, quite simply: "I do not doubt that Dr Arenson's proposed class action interested the public, and I appreciate that it attracted media attention. However, the fact that a case is interesting to the public doesn't mean that it's public interest litigation. Nor does it insulate the person bringing the proceeding from an award of costs against them."

The lawyer handling the case for Dr Arenson noted that they never went into the case for the money. "Dr Arenson's loss was only a few dollars put into two parking meters, and a $31 fine. But this was all about small wrongs being multiplied over a great number of people. We still think the city is making money illegally from parker's pockets, and we want to investigate this in a transparent manner. We are open to making a non-financial settlement if it leads to an impartial investigation that is publicly available."

As Justice Perell would summarise for him, don't hold your breath.

With all the frustration and anxiety that escalates as people drive around a busy city, it's little wonder that road rage incidents have become the fastest growing crime statistic in modern days.

The expression 'road rage' was adopted in the U.S. in 1988 after a rash of highway shootings occurred in Los Angeles. There are now 300 cases a year where motorist fury has resulted in fatality or serious injury.

New York and Dallas are the 'Road Rage Capitals' of the U.S., and London and Birmingham lead the league tables in the UK.

But we are soaring ahead of America in a spree of Bike Rage incidents, including altercations between cyclists and motorists, or sometimes, cyclist upon cyclist.

I find London taxis to be life's greatest luxury, and always wonder how the poor cab drivers remain relaxed at the wheel for hours at a time.

They are also victims of the cameras that endlessly roll, capturing any of their slip-ups or traffic violations, with a ticket very efficiently being dispatched the following day, photographic evidence included, making any resistance futile.

But cab drivers generally seem to take this so evenly, so blithely, I assume they are popping Prozac all day and night.

If I weren't so lazy and also hopeless at mathematics, I am sure that I could prove it is cheaper to travel by taxi than to purchase, insure, service and fuel a car, and then add the parking bills and parking fines you have accumulated, plus the cost of your resident parking permit, added to the congestion charge levied for entering cities.

In Greece an extraordinary 25% of monthly income is spent on petrol. We may believe that gasoline is very expensive in Britain, but in fact we offer a more economic tankful than many other nations.

Norway provides the most expensive petrol in the world, because motor fuel is burdened with both a road tax and a CO_2 tax.

Fortunately, Norwegians are more highly paid than in most other countries, so only 7.4% of their wages goes on motor fuel. And British petrol stations are a bargain compared to those in Turkey, the Netherlands, Italy and Denmark.

If you moved to Saudi Arabia or Libya you would only pay about 8p a litre, or simply drill a hole in your back garden and have a personal oil well.

But Venezuela is the place to set up home if you are seeking the best deal for filling up your car – it costs just 2p a litre.

President Hugo Chávez controlled prices in the South American country. His citizens consider cheap fuel a birthright; riots swept a previous government from power when it attempted to raise prices, and hundreds died in the rioting.

The president decided that cheap petrol was a small price to pay for a riot-free reign.

In Britain we used to be one of the world leaders in car production, dwarfed by only the might of Detroit.

Now, America is a midget car manufacturer compared to China, which makes seven times as many cars each year.

Japan follows, but with only the half the output production of China. Then comes Germany and South Korea, and even India now makes more cars than the USA.

You won't like to hear this, but Iran manufactures more cars than the UK, as does Mexico. More sadly, Italy, home of the world's most exotic automobiles, and of course the mighty Fiat range, now produces fewer vehicles than Thailand, Poland, Slovakia, Belgium and Malaysia.

And with the new super tax on Italian luxury goods, even Ferraris are being left unsold.

There are now one billion cars on the world's roads, and most of them seem to be in central London whenever I venture out.

But joyfully, in the back of a London cab, you cruise down the special bus and taxi lanes, and the drivers are very adept at avoiding most of the jams.

I have decided that I shouldn't publish my meticulous treatise on the fundamental benefits of selling your car, and travelling by cab.

If people knew what a bargain taxis currently provide, I would never be able to locate one. Or cab drivers would hike their prices to the levels they deserve for making life so cushy for the rest of us.

If you have ever sat in the back of a New York cab, cramped, dirty, with a less than knowledgeable driver, you will share our gratitude for the London Taxi – my most treasured luxury.

Hanging monastery at Datong in China

Built over 1,500 years ago by a monk named Liao Ran, into a cliff 276ft off the ground to avoid flooding from snow on the peaks above, the temple is a popular tourist attraction. The vertical pillars visible in the picture are only put there to reassure visitors that the structure is safe. The real crossbeam supports are embedded horizontally, deep into the mountainside.

Monks and nuns can be the most fearsome creatures on earth.

Datong is not the only monastery built onto a cliff face in China. It appears these are favoured sites for monks to properly explore their inner spirituality.

In the year 747 a Buddhist holy man was offered the task of ridding a mountain in Bhutan of evil spirits that haunted a cave. The cave was on a cliffside, inaccessible to humans but ideal for evil spirits to emerge and cause misery, and to then return to their secure lair.

The holy man meditated upon the cliff until he was able to assume the form of a wraith on the back of a giant tiger, and defeat the spirits.

A monastery was built upon the spot of his victory, to represent the triumph of good over evil, though in essence it represents the triumph of architecture over gravity. The temple's name translates as Tiger's Nest, and clings improbably to the side of the cliff.

If you are prepared for a 2,300 ft ascent up a sheer trail, the monks will welcome you with tea and prayer flags.

Ever since the global success of Bruce Lee movies, we have come to associate Shaolin temples with martial arts training.

Chinese fighting styles have developed over the centuries; monks and soldiers needed training in self-defence, and learned about strikes, throws, joint manipulation and pressure-point attacks.

Much is made of the philosophical influences on the techniques, though mystical aspects are of little consolation if you are on the receiving end of a fist to your Adam's apple.

There are a number of fighting styles that are the specialist trademark of each temple.

Besides the familiar Kung Fu, you could master Eagle Claw, Praying

Mantis, Bagua, White Crane, Hung Gar, Hsing I, Bak Mei Pai, Jow Ga, etc.

I had vaguely heard of the Boxer rebellion in 1900, when the Righteous and Harmonious Fists rose up against foreign occupiers and Christian missionaries in China. I didn't know that the boxer rebellion name was attached to battles because of the martial arts practiced by the rebels.

Chinese fighting styles became more accessible to the general public, and many martial artists were encouraged to openly teach their skills to promote national pride and build a strong nation, after the Chinese republic was formed.

In the 1936 Olympic games, a group of Chinese specialists demonstrated Kung Fu to an international audience for the first time.

Many nations have developed their own variants, including Systema, the Russian technique, Krav Maga, the Israeli style used by Mossad agents, Savate, a particularly vicious French style, Chio Kwang-Do from Korea, Aikido and Karate from Japan.

America is at the forefront of Close Quarter Combat, using a mixture of the most unpleasant moves involving gouging, and the Emerson system employed by special operatives of the Marine Corps.

But be warned. If you ever upset the wrong nun, there are nunneries that are producing young women fully trained in death grips and instant neck snapping.

Seen here in 1985, 69-year-old Fu Shu-yun was still a fearsome martial art champion, after representing China in the 1936 Berlin Olympics.

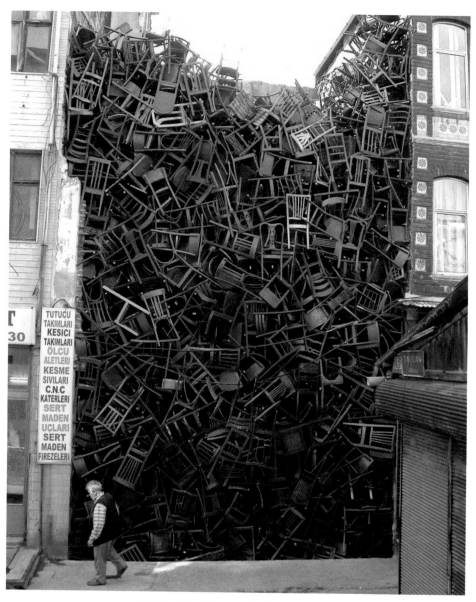

Doris Salcedo, installation at the Istanbul Biennial, 2003

Salcedo filled the Istanbul Biennial space between two buildings with 1,550 chairs "evoking
the masses of faceless migrants who underpin our globalised economy". She often takes
specific historical events as her point of departure, conveying burdens and conflicts with
precise and economical means.

When you hear 'Chippendales' do you think of chairs?

Thomas Chippendale was a London cabinet maker, chair and furniture designer in Gothic, Rococo and Neoclassical styles. His book, *The Gentleman and Cabinet Makers Directory*, was published in 1754 and became a bible for woodworkers and interior designers. Chippendale himself was commissioned by aristocratic clients to design entire furnishing for their stately homes.

An ornate chest of drawers, the serpentine-shaped Harrison Commode dating from 1779 sold for £3.8 million at Sotheby's in 2010, three times its high estimate.

Even back in 1988 a Chippendale carved mahogany chair was sold at auction for over $1 million.

But the iconic Chippendale furniture legacy has now been overtaken by the 'Chippendales', a touring male dance troupe best known for its exotic striptease.

Members sport a distinctive bow tie, and white shirt cuffs worn on a bare torso. Since 1979 they have performed for mainly female audiences, and because of the high standard of choreography and staging, the Chippendales eventually legitimized male stripping as popular entertainment, providing the fantasy of a naughty night with the hunky clean-cut boy next door.

The Chippendale team are seen performing by 2 million worldwide each year, in cities in Central and South America, and over thirty European capitals.

According to the official Chippendale website, where you can see pictures of each breathtaking member (stop it now) of the group, they each rehearse for four hours per day, and apparently maintain a healthy

lifestyle and get a lot of sleep. Each Chippendale performer has his own distinctive look, and persona, so you can pick your favourite, depending on your preference for long golden locks, shaven heads, redheads or brunettes, and select from an assorted racial mix.

The Chippendales are forbidden from accepting tips from the clientele, but other male strippers leave the stage with wads of notes stuffed into their thongs, taken out happily when the thongs are removed.

Often, the female audience go wild at the sight of gyrating muscles slick with baby oil, and less fastidious groups try to raise the ante by wearing fireman, policeman, even gorilla costumes, or bizarrely employ bananas and whipped cream as props.

Some of the enthusiastic ladies remove their own tops, and need to be restrained from groping the performers, who occasionally have had to hide out in the bathroom, as women battled to reach them before they could escape out of a window into a getaway bus.

Bachelorette parties are an additional source of income, and Las Vegas is a popular venue for a memorable last night for a bride-to-be.

Over the years, there have been many legal barriers for the Chippendales to overcome, though these are usually conflicts with 'copycat' companies.

More seriously, its founding partners have both become infamous murderers. Paul Snider killed his estranged wife, Playboy Playmate Dorothy Stratten, and then himself.

Partner Somen Banerjee was charged with organizing a hit-man to murder a business associate.

Thoughtfully, he wanted to shield his wife from a wrongful death lawsuit and a $2 million fine, so he hung himself in his cell before his trial was completed, also avoiding a probable life sentence.

Perhaps they would have both been better off making decorative furniture.

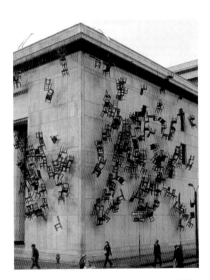

In 2002, the Columbian-born artist placed 280
chairs at the Palace of Justice in Bogotá, Colombia,
to pay homage to those killed there in a failed
guerrilla coup seventeen years earlier.

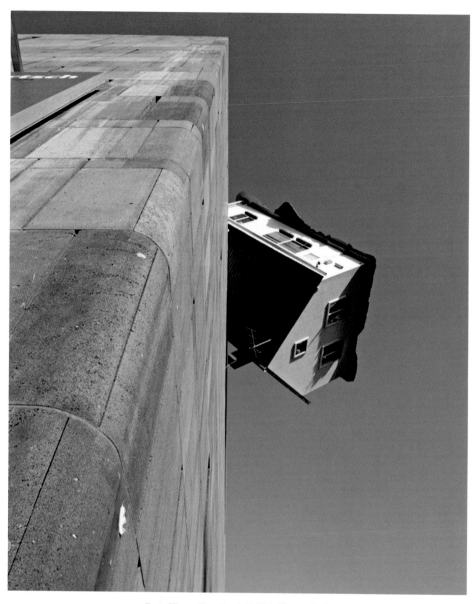

Erwin Wurm, *House Attack*, MuMok, Vienna, 2006

MuMok Curator, Edelbert Köb explains: "*House Attack* confuses our perception of art and everyday reality and in its striking appearance and humorous, dramatic staging of the banal is a perfect example of current developments in the artist's work". Erwin Wurm has always been involved in question and answer theories about sculpture, and the way it is constituted.

Being a witch can be a curse.

As departures go, being assassinated by having a house fall from the sky and landing on top of you would be considered one of the more unfortunate.

This was the unenviable fate of the Wicked Witch of the East in the legendary story about *The Wizard of Oz*. Young Dorothy was plucked from the dust bowls of Kansas by a tornado which lifted her farmhouse with her inside, and ended up crash-landing it directly upon the poor lady.

On arriving in a strange new land, Dorothy is hailed as a powerful sorceress and lauded by the little inhabitants, the Munchkins, as the vanquisher of the Wicked Witch who had enslaved them for years.

Dorothy is startled to see that she has indeed killed an old woman with a penchant for slavery, and stylish footwear.

In the book, it was silver slippers that adorned the witches feet; in the film these become ruby slippers.

This will not be the only case, I'm sure, of a homicide between women involving shoes.

Moving beyond the confines of storytelling, killing witches has been a centuries old pastime.

Prosecuted since ancient days, the practice of legally trying witches in Europe was banned in the 8th century by Charlemagne, as being un-Christian and generally a little barbaric.

However ritual burnings of women were commonplace across Europe in the 16th century during the Reformation, a time of religious unease and realignment.

The Malleus Maleficarum, a book on the prosecution and practices of witches written in 1486 and widely distributed with the birth of printing,

provided a handy guide for those seeking to accuse women of witchcraft; it provoked a witch hunt frenzy.

At the North Berwick witch trials of 1590 in Scotland over 70 women were accused of witchcraft, after being blamed for the bad weather that afflicted James VI of Scotland's voyage to Denmark to meet his betrothed Anne of Denmark.

The arbitrary and savage indictment of women who didn't fit society's rigid construct of femininity reignited in New England during the legendary Salem witch trials of 1692. The Puritanical town was already riven with petty squabbles and familial rivalries; it didn't help that a favourite meal amongst Salem's parishioners at the time was rye bread laced with hallucinogenic fungus.

When children of the townsfolk began to suffer from convulsions, contortions, and screaming fits, unpopular local women were accused of having cursed them.

A number of 'scientific' techniques were used to establish whether the accused was indeed a witch. Eye witness accounts from people who had dreamt that the defendant acted like a witch during their dream were accepted as legally binding.

The persecution of witches was not confined to the emphatic beliefs of Christians. Prosecution, torture and execution of witches is recorded across the world throughout history in nations that were believers in Islam, Hinduism and Judaism.

Witchcraft phobia is still acute in Nigeria where a potent mixture of Christianity and African beliefs has led to a lucrative witch-hunting business, in which even children are tortured and accused of witchcraft.

Over the past decade around 15,000 women and children have been accused and 1,000 murdered.

Bizarrely, contemporary witchcraft in the UK is on the rise, alongside an accompanying popularity in pagan belief. Practitioners of Wicca are rather more suburban than those popularized in myths such as Morgan le

Fay, the half sister of King Arthur, and are more apt to cast spells for promotions at work than powerful curses to harm enemies.

eBay is a rich source of paraphernalia for today's believers in black magic and spirits. Aficionados can snap up collections of dolls possessed by dead children, and pinecone white magic amulets with supernatural powers.

Just as the invention of printing caused the spread of *The Malleus Maleficarum*, the internet is now demonstrating that in the hands of slightly deranged people, technology can be as anti-evolutionary a tool as a book.

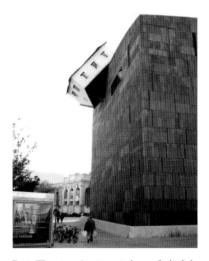

Erwin Wurm is an Austrian artist known for his light approach to formalism. He says: "If you approach things with a sense of humour, people immediately assume you are not to be taken seriously. But I think truths about society and human existence can be approached in different ways."

Lake Berryessa Spillway, Monticello Dam, Napa County, California.

Located in northern California, the Monticello Dam is the largest spillway in the world. This funnel-shaped outlet, allows water to bypass the dam when it reaches capacity, as it swallows a rate of 48,400 cubic feet per second.

The missing bathplug in your Russian hotel.

Have you ever seen a whirlpool? Neither have I, but apparently giant whirlpools suddenly materialize in our oceans on an apparent whim quite frequently.

Recently, two giant ones emerged in the Atlantic off the coast of Guyana, causing a sensation among oceanographers because it was so unprecedented in this part of the sea.

Basic details about size, speed, depth and rate of spin are limited. The whirlpools that exert a strong downward pull, the ones you should try to avoid during an ocean dip, are called vortices, and there is a particularly powerful, and seemingly permanent one off the coast of Norway – the Maelstrom.

Whirlpools, tens and sometimes hundreds of metres in diameter, may last for months or even years, before they get bored, and stop whirling.

In Scotland, between the islands of Jura and Scarba, you will encounter a permanent whirlpool, the third largest in the world.

In Scottish mythology, the Hag Goddess of Winter uses the gulf to wash her great plaid, and the roar of the coming tempest can be heard for twenty miles.

According to the Royal Navy, it is not officially un-navigable, but they describe it as very violent and dangerous, and that no vessel should attempt a passage anywhere nearby without local knowledge.

The closest I have ever been to a whirlpool is watching the bathwater gurgle down my bath plug hole.

For years, travellers to the Soviet Union were told to take their own bath plugs, because even the baths in the best hotels failed to provide them.

In the West, we sniggered that the Russians were incapable of sourcing enough rubber to manufacture plugs for baths or basins.

In fact, the reason was more prosaic, not to say hygienic. Russian's simply prefer to wash in running water, and find the idea of sitting in your own dirty water repellent.

It is a commonly held belief that in the Middle Ages people in Britain simply did not wash or clean their teeth.

In fact, personal hygiene amongst Britons was better than commonly perceived.

Crusaders had brought back soap from the Far East and Europe, and though most people washed in barrels of cold water, wealthy people were treated to water that had been boiled.

Teeth cleaning involved the use of herbs, and abrasives like the ashes of burnt rosemary.

People tried to look after their teeth, because the only remedy for a toothache was to have the offending molar pulled out without any anaesthetic.

Women in particular were very concerned not to present a mouth full of missing teeth, and took great care to avoid losing them, as dentures had not yet been invented.

The Black Death in England that struck in 1348 was blamed on two factors.

The rush flooring in people's homes was too infrequently renewed, so the bottom layers were left undisturbed, often for twenty years, harbouring spit, vomit, dog urine, scraps of fish, ale droppings and much worse.

Sweet smelling herbs such as lavender, camomile, and rose petals were employed to disguise the smell. Vapours rising from the floor were thought to have spread the plague.

But worse was to be found on the streets, where dung and entrails were commonplace, and it wasn't until 1388 that Parliament decreed that you

would receive a sharp fine if you didn't take your own excrement and dump it in a ditch, or river.

The value of cleanliness during the Middle Ages can best be testified by the popular Latin cry of the time: Venari, ludere, lavari, bibere – Hoc est vivere! (To hunt, to play, to wash, to drink – This is to live!)

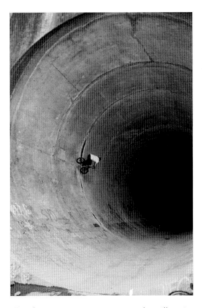

For obvious reasons swimming near the spillway is prohibited. There are buoys strung across the lake to discourage boaters and swimmers from approaching the spillway and the dam. During the drier months, when Lake Berryessa's water level is well below the rim of the spillway, skateboarders and bikers sometimes use the drain's horizontal exit as a skatepark.

Pierre Vivant, *Traffic Light Tree*, 1998, Docklands, London

Created for a competition run by the Public Art Commissions Agency, the sculpture is 8 metres tall and contains 75 sets of lights, each controlled by computer. Initially located on a roundabout near Canary Wharf, it was removed in December 2011 as part of remodelling work. It will remain on the Isle of Dogs, but the exact location is still to be decided.

The slow driver you are holding up is a moron.
The fast driver overtaking you is a maniac.

I remember a time when car owners enjoyed the recreation of 'motoring'. They would drive for the simple pleasure of getting behind the wheel for a day's spin, enjoying the highways and byways.

No longer.

But however clogged and unpleasant road transport is these days, we are blessed at not having to commute along the North Yungas Road, affectionately known as The Death Road, leading from La Paz, Bolivia's capital, to the Amazon region of the Yungas.

Legendary for the extreme high risk involved, this thin curl of concrete traversing undulating mountains, offers sheer drops every inch of the way, pounded by heavy trucks and buses, with barely enough room for them to navigate around each other.

Between 200 and 300 travellers are killed annually – you will find the route is decorated with many crosses marking the points where vehicles have plummeted.

In China, another road that winds across mountains was built in part as a 1,200m tunnel, by the locals in Taihang.

Many villagers died constructing it but more people continue to perish on the funfair thrill-a-second ride.

The Russian Federal Highway connects Moscow to Yakutsk, the largest city built onto continuous permafrost. It gets colder then Antarctica.

Winters last ten months, so driving will often be subject to heavy snow, ice, and poor visibility.

This is a relatively easy task compared to tackling a trip to Yakutsk during July and August. Because there is no asphalt, the permafrost turns into a muddy hellhole, not least because local pirates take advantage of the

jams created to effortlessly loot vehicles or kidnap passengers from nice, but trapped, cars.

I have yet to visit Greece, but would be prepared to detour and try my hand at the Patiopoulo-Perdikaki Road.

Basically it is a narrow busy dirt track, with a steep climb and descent, and many large potholes, with only gravel to provide grip.

Naturally, there are sheer drops on either side, with no guard rails, but you will come across many pedestrians, livestock, trucks, buses and other hopeful motorists.

There are no lines to determine where the edge of the road might be, so not surprisingly many of the accidents on this road occur at night.

Closer to home, thrill-seeking tourists have also heard of our A682, running between Lancashire and Yorkshire. It has claimed the deaths of over 100 victims on just one 15-mile stretch in recent years.

Sunday morning is a cherished time to explore; early birds will see that this is the window widely favoured by motorcyclists testing the speed and road-holding prowess of their mounts, and the limits of their bravery.

I hope it's not too distasteful to note that the A682 is known to hospitals throughout the land as a reliable provider of organs for transplant procedures.

Britain's roads in general are not home to the world's most dangerous drivers. These can be found in Rome, Naples, Milan and just about every other major Italian city. Italy has the highest number of car accidents in the EU, followed by Poland and then Greece.

Collisions are chiefly the result of the flagrant flouting of traffic laws: speeding across pedestrian crossings, tailgating, gesticulating theatrically and disregarding traffic lights and other road signs.

The biggest problem, however, is apparently many male drivers spend more time staring at passing signorine than keeping eyes focused on the road. *Che sorpresa!*

The 69 km North Yungas Road in Bolivia claims many lives and is
officially designated the world's most dangerous road. A presenter of the
BBC's *Top Gear* experienced the terror of the road for himself whilst
filming an episode for the show called 'Bolivia Special'. The dangers
became apparent when the surface began to crumble under the wheels of
his Range Rover, as it teetered over the edge while passing another vehicle.

A photograph by Matthew Makes of E 11, or 'Sheik Zayed road', in Dubai taken from the
top of the Burj Khalifa skyscraper. The buildings in the photograph are all situated on E 11 –
the longest road in the United Arab Emirates. The Burj Khalifa is the tallest manmade
construction in the world, at 2,723ft. The building has returned the location of Earth's tallest
freestanding structure to the Middle East, where the Great Pyramid of Giza claimed this
achievement for almost four millennia before being surpassed in 1311 by Lincoln Cathedral
in England.

If you get a chance, please pass this to Sheikh Maktoum bin Rashid al Maktoum.

Dubai was officially established in 1833 by Sheikh Maktoum bin Rashid al Maktoum when he persuaded 800 members of the Bani Yas tribe to move down there from Saudi Arabia. He chose wisely, because its geographical location made it an important trading hub and sea port.

The al Maktoum family have ruled it ever since, and it is now the powerhouse of the United Arab Emirates, and the most expensive city in the Middle East to live in; it has seen tremendous growth in tourism and real estate development, and is the centre of the entire region's financial services.

Between 1968 and 1975 the city's population grew by over 300%, but by 2005 only 17% of Dubai's population was from the UAE. Revenues from oil and natural gas account for less than 6% of Dubai's revenue, and oil reserves are expected to be exhausted within the next twenty years, hence the drive to turn Dubai into a global tourist destination.

With fifteen million visitors a year, and hosting an international film festival and pop concerts by stars including Elton John, Celine Dion, Aerosmith, Pink, and Coldplay, the *New York Times* described Dubai as, "the kind of city where you might run into Michael Jordan at the Buddha Bar or stumble over Naomi Campbell celebrating her birthday with a multi-day bash".

Miles of the surrounding desert sands are being reclaimed to create the world's biggest theme park, Dubailand, twice the size of the Disney World resort, and costing $55 billion and rising.

It will include Ferrari World, Sahara Kingdom, the world's biggest Ferris Wheel, an enormous Six Flags funfair, a Legoland park, IMAX theatres, four shopping malls, four immense hotels and apartment

blocks – if your children persuade you to emigrate and live in the theme park permanently.

As visitor numbers grow, the Dubai World Central al Maktoum International Airport is being completed; it will be the largest in the world with a capacity for millions of tons of passengers and cargo.

Dubai is also developing a high speed rail link to connect it to Europe.

It is already the 8th most visited city in the world, and the Middle East's shopping capital, with over seventy shopping malls, including the world's largest. Inside the 12,000,000 sq ft Dubai Mall, you will find endless rows of the world's most renowned high-end stores and boutiques; it also offers a full size indoor 'snow' mountain to ski down, funfairs and countless restaurants and burger bars.

The top architectural firms from across the world have had a field day in Dubai, taking skyscraper design to new heights (sorry).

In 2010, the Khalifa Tower opened as the world's tallest building. Its design was intriguingly derived from the patterning systems embodied in Islamic architecture, with the triple-lobed footprint of the building based on an abstracted view of a desert flower native to Dubai.

Dubai is also home to the only 7-star hotel in the world, the Burj al Arab, designed by Tom Wright in the style of the boat sail of a dhow, and built on an artificial island connected to the mainland by a private curving bridge.

The Royal Suite is available at $28,000 a night, and you can dine in the Al Mahara restaurant, surrounded by a large seawater aquarium holding 35,000 cubic feet of water, and built using acrylic glass 18 centimetres thick to withstand the water pressure.

Another extraordinary architectural scheme is Palm Island. Artificial peninsulas were constructed using sand dredged from the bottom of the Persian Gulf. The breakwater for Palm Island needed seven million tons of rock, with each boulder being placed individually by crane. Construction was completed in just four years, finishing in 2006.

Along with the humbly named 'The World' and 'The Universe', two other artificial archipelagos, and other smaller Palm Islands, the coastline of Dubai will be extended by 520 kilometres – offering a multitude of golden sandy beaches for sunbathers.

Why am I writing this travelogue for Dubai, for which I promise you I have not been offered a stipend, a freebie in the Burj, or even a night out at the mall Burger King? I went to Dubai rather reluctantly, to attempt a family winter holiday, and loved every minute.

The locals were charming and I was entranced by the Sheiks wandering around the malls in their Persil-white starched robes, each with a train of a dozen giggling black burkha-clad wives, clutching their black Amex cards, which I don't imagine ever get maxed-out. The women did not appear to be oppressed in any visible way.

Our hotel had 42 restaurants, catering to most international cuisines, and all reached by little boats that circle the waterways curling around the hotel grounds.

Please pass on this rave review to Sheik al Maktoum's private secretary, and explain I would be delighted to enjoy a complimentary stay in the Royal Suite at the Burj, and would like to offer similar hospitality to many cynical friends who refuse to accept that Dubai is a simply lovely treat.

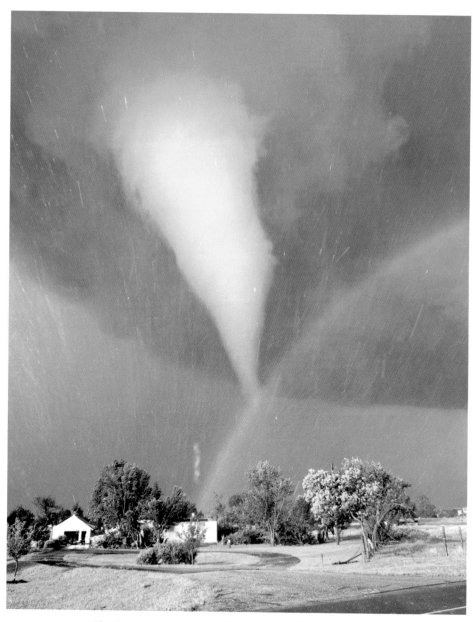

This photograph shows a white tornado cloud descending from a dark storm. By coincidence, the tornado appears to end right over a rainbow. Over 1,000 tornadoes, the most violent type of storm known, occur on Earth every year. The moment was captured by storm chaser Eric Nguyen in Kansas, 2004.

Gone with the *Wind* is going to be the biggest flop in Hollywood history.

Gary Cooper, who had turned down the role of Rhett Butler, made that prediction and thoughtfully added, "I'm just glad that it'll be Clark Gable who's falling flat on his face and not me".

In many ways, although it was a powerful and much-admired film, *Gone with the Wind* was a bit windy. When I re-watched it recently, I found my mind wandering trying to recall other films with 'wind' in the title.

Inherit the Wind had Spencer Tracy and Fredric March as adversaries in a courtroom drama based on the Scopes trial of 1926, about a teacher being prosecuted for teaching Darwinism.

Written on the Wind was a Douglas Sirk classic starring Rock Hudson and Lauren Bacall in a tale of forbidden love in suburban 1950s America.

A Mighty Wind was Christopher Guest's charming mockumentary following a folk orchestra.

Whistle Down the Wind was an early Bryan Forbes success with Alan Bates, that introduced young Hayley Mills.

A High Wind in Jamaica was a lacklustre 1960s film starring the overwrought Anthony Quinn.

Windtalkers was a tremendously dull John Woo film with Nicholas Cage.

The Wind that Shakes the Barley was a typical Ken Loach film, typical in that anyone sentient would only manage 20 minutes of it, though naturally, it won the Palme d'Or at the Cannes Film Festival in 2006.

The Wind and the Lion was an entertaining Sean Connery vehicle made in 1975, slipped in between James Bond roles, and allowing him to slip into some splendid Arab robes.

I was just beginning to wonder whether *Twister*, a mildly interesting film about tornadoes could be classified as a 'wind' movie, when I got caught up once again in the travails of Scarlett O'Hara.

As an indication of my spectacular social life, I spent the rest of my enticing Saturday night exploring famous tornadoes, hurricanes and typhoons. I quickly learned that in March 1925, what was to become known as the Tri-State Tornado hit the United States.

The 219-mile path it followed ripped through southeastern Missouri, southern Illinois, and into southwestern Indiana.

It took three and a half hours to blow itself out, taking the lives of 695 people.

Advances in research and early detection have helped reduce the number of fatalities in the U.S. over more recent years.

Unfortunately, Bangladesh is still considered home to the world's most frequent, and deadliest tornado outbreaks.

The Daulatpur-Saturia that hit in April 1989 took 1,300 lives, and the injured were estimated at 12,000 as the tornado destroyed virtually every structure it touched.

A further five of the world's most powerful tornadoes focused on Bangladesh in 1964, 1969, 1973, 1977 and 1996.

Little is known about the savage tornadoes that hit the Soviet Union in June 1984. A group of them concentrated on Western Russia, destroying reinforced concrete structures, and flattening over 1,000 homes across a swathe of 400,000 sq m.

More recently in August 2011 a tornado roared through the Russian city of Blagoveshchensk on the border with China. Advance warnings evacuated the 225,000 inhabitants, resulting in just one death, though the infrastructure of the city was largely decimated.

Russian cinema is renowned for many masterpieces over the last sixty years.

However, Russia recently made its first disaster movie set in Moscow,

with *The Darkest Hour* telling of an alien invasion attempting to steal mankind's electrical supplies.

Despite a $30 million budget, reviews were mixed.

A more balanced notice pointed out that "the film goes from forgettable to barely forgivable in record time".

The producer, Timur Bekmambetov hoped that his next feature would redeem his reputation – it was the eagerly anticipated, by some, action blockbuster *Abraham Lincoln: Vampire Hunter*.

Gary Cooper turned down *Gone With The Wind* in order to star in *The Real Glory* directed by Henry Hathaway. Its plot involved a small American contingent trying to train rural tribesmen to defend themselves against fanatical Muslim radicals in 1906 Philippines. It sunk without a trace.

Burj Al Arab hotel, Dubai, 22 February, 2005

To help promote the Dubai Tennis Tournament, Andre Agassi and Roger Federer played on
a specially prepared court for some 20 minutes on top of the hotel's helipad which stands
211 metres high and has a surface area of 415 sq metres.

Death of a Wimbledon Finalist.

That was the title of a book by Dan Davey published in 1991, in which its main protagonist Detective Inspector Victor Arliss, known by his epithet 'The Vicar', investigated a merciless death surrounding a Wimbledon Championship match.

Tennis has provided the background to many thrilling tales including Alfred Hitchock's *Strangers on a Train.*

Caravaggio, the renaissance master, led a tumultuous, notorious life and left behind a mystery surrounding his death, as well as a great number of masterpieces. Admired by younger artists in Rome, he was a legendary roué and brawler.

Following a tennis match in 1606 against a love rival, Ranuccio Tomassoni, both men drew their swords and Caravaggio, attempting to slice off his opponent's testicles, cut his femoral artery leaving Tomassoni crashing to the ground and bleeding to death.

Caravaggio fled to Malta and then on to Porto Ercole on the Italian coast, and scholars now assume his sudden death there was a result of Tomassoni's friends tracking him down and avenging their colleague.

Caravaggio's body was never found, and it wasn't until the 20th century that his importance to Western art was fully celebrated.

Tennis has proved a hazardous sport even to the participants not actually competing.

A linesman, Dick Wertheim, was killed in 1983 at the U.S. Open when an ace by Stefan Edberg struck him on the head with such force he slammed backwards in his chair, cracking his scull on the hard court surface.

The modern game originated in 19th century Birmingham as 'Lawn

Tennis', and the rules have changed little, other than the adoption of the tie-break.

Historians believe the game's origins lay in 12th century France, with the ball being struck with the palm of the hand; Louis X was a keen player, keen enough to build the first enclosed courts so he could play year round.

But after a particularly exhausting game, Louis drank a large quantity of chilled wine, and subsequently died of pneumonia or pleurisy.

King Charles V of France was another enthusiast, who set up a court at the Louvre.

But Real Tennis, as it is officially known, became the most favoured pastime of Henry VIII, before he grew too portly, or was too exhausted by his numerous wives, to move around much.

Even after the introduction of the tie-break, a first round match at Wimbledon in 2010 went on between Nicholas Mahut and John Isner on the 22nd, 23rd and 24th June, requiring 183 games and taking 11 hours and 5 minutes of playing time. The fifth set alone took 8 hours and 11 minutes.

Compare that to the 23 minutes it took Suzanne Lenglen to defeat Molla Mallory, 6-2, 6-0, in the quickest ever win at Wimbledon in 1922. Admittedly it was only a 3-set match.

Probably the most memorable game for lovers of the bizarre was the 1977 U.S. Open match between Renée Richards and Virginia Wade.

Richards was making her debut in the women's singles 17 years after she had played as Richard H. Raskind in the men's singles.

Following a 1975 sex-change operation, Richards was accepted as a legitimate female opponent. Wade beat her in straight sets.

Earlier, in 1973 a more realistic battle of the sexes took place in Houston, Texas, when Bobby Riggs, a one-time top-ranked tennis champion but now 55, claimed that any halfway decent male professional would easily defeat the world's No.1 female champion.

As everyone other than Bobby Riggs predicted, Billie Jean King took

up the challenge and beat him in a closely fought but decisive victory, 6-4, 6-3, 6-3.

I'm sure it must have been a more captivating match than the one between Tony Pickard, the British Davis cup player, and New Zealander Ian Crookenden, playing in Rome in the Italian Championships.

Apparently the game was so very dull that not only were the crowd bored, but the line judges were also losing interest.

Pickard takes up the story: "It was a vital game point. He served and it was at least nine inches long.

The umpire looked to the baseline judge for the call, but he was turned round buying an ice cream over the fence".

Crookenden won the point and went on to win the match. "I felt as sick as a pig", says Pickard.

Renée Richards was an American professional tennis player who underwent sex reassignment surgery in 1975. As a result she was denied entry into the 1976 US Open by the United States Tennis Association, citing an unprecedented women-born-women policy. She took the issue to the New York Supreme Court in 1977 which ruled in her favour. The case was an important advance for transsexual rights. The made-for-television film *Second Serve*, based on Richards' life, resulted in its star, Vanessa Redgrave, receiving nominations for an Emmy and a Golden Globe for her performance. Richards now works as an ophthalmologist.

P&O Building, Leadenhall Street, City of London

This is a photograph of the 1969 version of the building undergoing demolition in 2007.
Project director Matthew White said: "When you demolish the building, you have to take
the weight off the structure first, from the bottom up. Eventually the beam will be
deconstructed at roof level, leaving the core, which will be demolished from the top."

Every act of creation is first an act of destruction.

I don't imagine Pablo Picasso was referring to the destruction of this building in the City of London when he made his observation, though in fact it was a particularly creative feat of demolition.

The Peninsular & Oriental Steam Navigation company, or P&O as it's known, had its headquarters for well over a century at Leadenhall Street. The building was redeveloped in 1969, and was considered one of the most advanced architectural breakthroughs in the UK, widely influenced by Mies van der Rohe.

Its use of a central compressed concrete core, with suspended floors, was the benchmark of tension structure. It was so complex it took two years to demolish.

The site will be re-opened as a Richard Rogers spectacular in 2014, already known as the 'Cheesegrater' because of its wedge-shaped profile rising up to 737ft, and with similar exterior glass lifts to the neighbouring Lloyd's building also designed by Rogers.

P&O have been making waves since the early nineteenth century, but was sold in 2006 to Dubai Port World.

London is home to many other elderly but robust organisations, trading happily since the 17th century.

The Whitechapel Bell Foundry is listed in the *Guinness Book of Records* as the oldest manufacturing company in the UK, dating back to 1570. Situated in the East of London, the foundry's main business is the bellfounding and manufacture of church bells and their fittings and accessories. One of London's most famous landmarks, Big Ben at the Palace of Westminster, was cast in 1858 and at 13½ tons is the largest bell ever cast at the foundry.

The London Gazette – the oldest surviving English newspaper – was first published as *The Oxford Gazette* on 7 November 1665.

Charles II and the Royal Court had moved to Oxford to escape the Great Plague of London, and courtiers were unwilling to touch, let alone read, London newspapers for fear of contagion.

The King eventually returned to London, and the *Gazette* moved too, with the first issue of *The London Gazette* being published on 5 February 1666.

It is considered to be the most important official journal of record of the British government in the UK, in which certain statutory notices are required to be published.

The auction house Spink and Son Ltd. was set up in London in 1666. Originally specialising in numismatic objects (that's coins and bank notes to you and me), today it has broadened its scope to deal in antiquities, jewellery, stamps, medals, autographs, books and fine wines.

Founded in 1672 in Cheapside, Hoares is the UK's oldest privately owned banking house. The business prospered most fruitfully during the 18th century; its founder Richard Hoare was knighted by Queen Anne in 1702 and went on to become Lord Mayor of London.

His grandson, Henry Hoare, or Henry the Magnificent as he was known, dominated the family and the business through his immense wealth and force of personality.

His epithet came about from his influence as a great Patron of the Arts, but more specifially because he designed the spectacular gardens at the Stourhead Estate in Wiltshire.

Established in 1676, James Lock & Co. Ltd. is the oldest hat shop in the world, and one of the oldest family owned businesses still in existence.

A postcard from abroad was once delivered to the shop, simply addressed to "the best hatters in the world, London", and ask any London taxi driver for "Lock's", and he will deliver you to number 6, St. James's Street. Esteemed previous patrons include Sir Winston Churchill, Charles

Chaplin, Sir Anthony Eden, the Duke of Wellington and Admiral Lord Nelson.

Toye, Kenning & Spencer is a British uniforms and medals manufacturer which was started in 1685, and is still run by members of the Toyé family. They arrived in England as Huguenot refugees, sailing into the Thames disguised as cattle-dealers.

However impressive the staying power of these organisations, consider Kongo Gumi, the world's oldest company founded in Japan 1,435 years ago in 578AD. It is still trading nicely today in the construction industry.

Henry Hoare II 'The Magnificent' (1705-85) painted in 1726 by Michael Dahl and John Wootton, in the Entrance Hall at Stourhead, Wiltshire. Stourhead has been used as the setting for many films including *Pride and Prejudice* starring Keira Knightley in 2005. The gardens were designed by Henry and laid out between 1741 and 1780. The inspiration behind their creation were painters Claude Lorrain, Poussin, and Gaspar Dughet.

This image shows where a poor neighbourhood in Guatemala City plummeted some 30 storeys into the Earth in February 2007. The 330-foot-deep sinkhole swallowed about a dozen homes and was blamed for the deaths of three people — two teenagers, found floating in a torrent of sewage, and their father, who was pulled from the chasm.

Miles beneath your feet, the Earth is trembling.

Many miles below the Earth's surface, the ground shakes silently in a series of endless earthquakes that nobody can feel; scientists, however, can detect and measure them.

Some of these tremors cause seismic disturbances, but others are thought to relieve the stress, creating what is usually a balanced harmony.

Twenty-four orbiting satellites can measure ground motions as tiny as a fraction of an inch. Sadly, this doesn't help if Nature springs a surprise, and behaves unpredictably.

Guatemala has never recovered its equilibrium since it became clear that giant sinkholes could appear unannounced at any time, and swallow large buildings, or streets.

Its population of four million must be some of the most stoic inhabitants of Earth, knowing that the ground their city is built upon is highly unstable, and could collapse beneath their feet momentarily.

There is a long roll-call of other unsual natural disasters around the world, equally horrifying to imagine.

The St Pierre snake invasion in Martinique began straightforwardly enough on the volcanic island in the West Indies. Near the main volcano, fresh vent holes started steaming and mild earth tremors began occurring during April 1902.

By early May, volcanic ash began to rain down continuously, with the foul odour of sulphur filling the air.

When their homes on the mountainside became uninhabitable, hundreds of Fer de Lance snakes slithered down and invaded the town of St Pierre.

The 6ft long serpents lethally bit fifty people and many animals, before

a herd of small mountain lions also took shelter in the town, and killed all the snakes.

But more was to come.

A landslide of boiling mud spilled into the sea, creating a tsunami that took hundreds of lives on 5th May. Three days later the volcano finally erupted, sending an avalanche of white-hot lava straight into the town, completely obliterating St Pierre in its entirety. Of its 30,000 population, there were only two survivors.

1902 was also an unfortunate year for the town of Birmingham, Alabama; two thousand people had jammed into the enormous Shiloh Baptist Church to hear an address by Booker T. Washington.

There was an altercation amongst the congregation, and someone misheard 'fight' for 'fire'. In the stampede that followed, 115 were trampled or suffocated to death as people piled 10ft high trying to escape.

There was in fact, no real fight, let alone fire.

One of the more nightmarish of events took place in Gillingham in Kent in 1929. They held a popular annual fire-fighting demonstration at the Gillingham Parish Fete, using a specially constructed makeshift 'house' fashioned out of canvas and wood. Each year a few local boys were thrilled to be selected for the show.

Nine boys and six firemen dressed up as a wedding party, and climbed up to the third floor of the 'house', waving to the crowds.

The notion was to light a smoke fire on the first floor, rescue the wedding party with ropes and ladders, and then set the empty house ablaze to demonstrate the power of fire water hoses.

By some error, the real fire was set first.

The spectators, assuming the bodies they saw burning were dummies, cheered and clapped, whilst the remaining firemen outside directed streams of water over what they knew to be a real catastrophe. All fifteen people in the house died.

In 1971, a Soviet drilling rig punctured a massive underground cavern

of natural gas. The surface collapsed, swallowing the drilling team and equipment, and poisonous fumes began emerging from the hole.

Fortunately, it was in a largely uninhabited desert in Turkmenistan. But the crater had now grown to 328ft in width, and continued to still enlarge, so the decision was taken to set it on fire and prevent a potential catastrophe.

It has been burning for 41 years, and makes for a spectacular sight after dark, if you are planning an exotic hiking holiday.

A view directly into the abyss of another sinkhole in Guatemala City which reportedly swallowed an entire three-storey building, this time in June 2010. It is likely that the sinkhole had been weeks or even years in the making — scientists said that floodwaters from tropical storm Agatha caused it to finally collapse.

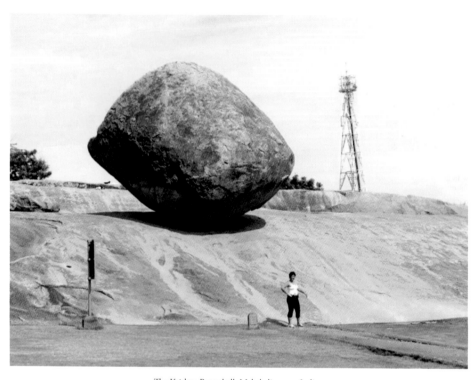

The Krishna Butterball, Mahabalipuram, India.

Krishna's Butterball is a giant natural rock, approximately 5 metres in diameter, seemingly in defiance of all known laws of physics; it perches on a hillside, resting at an angle of 45 degrees.

Bowled over by big boulders.

I am not counting Ayers Rock, often described as the world's biggest, in the Red Centre of Australia.

One reason is that Australians themselves are quick to point out that their own Mount Augustus in Western Australia is two and a half times bigger than Uluru, Ayers Rock's official name, and is in effect the true record holder.

But let's discount both of these rocks in the same way you would discount Everest as a rock.

To nearly all of us, they would be called mountains.

However, they make it into Australian tourist guides as the world's biggest rocks, because Australia's tourist board wants to attract tourists.

If you are indeed looking for a big rock, that can reliably be called the Earth's largest boulder, you need to visit California, and ask directions for Giant Rock. It's in the Mojave desert; the granite stone had been seen as holy ground by Native Americans, and Indian tribes convened here each year to celebrate the coming seasons; their shaman drew spiritual strength via the spirit of the rock itself.

The boulder stands about seven storeys tall, occupying 5,800 sq ft, and unsurprisingly became a shrine and centre for UFO conventions. 10,000 believers regularly attended seeking alien spirituality.

In the early 1930s, a middle aged prospector Frank Critzer decided to fashion his house under the great rock, in anticipation of enjoying cooler temperatures under its shade in summer, and the need to burn less fuel to keep warm in winter.

Shortwave radio was his hobby, and he erected a large antenna on top of his little house for better signal strength.

Considered a strange soul by other locals, and being a German immigrant always ready with his rifle to ward off visitors, he came under suspicion as being a German spy during World War II, and was killed in a botched law enforcement raid on his dwelling in 1942.

In 1947, George Van Tassel, a former aeronautical engineer who had previously worked with Howard Hughes as his personal flight inspector, applied for a contract to develop an airpstrip and created the Giant Rock Airport and Cafe, which operated until 1975.

Van Tassel believed the rock had great channelling power due to its piezosonic characteristics (that's electricity created by pressure, to the likes of me). He began a series of weekly meditations beneath the boulder that allegedly prompted contact with extraterrestrial beings.

In one encounter, Van Tassel recorded that he was led to a hovering spaceship, where he was treated to a tour of the craft during which the aliens demonstrated to him the principals of cell rejuvenation. This lead him to create 'The Integratron' – a machine designed to reverse the ageing process by recharging cell structure, using a powerful negative ion field.

Sadly for all of us, Van Tassel died before he could complete this breakthrough.

If you want to buy your very own boulder to decorate your garden, you could visit Buymyrocks.com where they explain "Mother Nature's stonework can add a touch of class to your property". They carry a varied supply and claim they are "usually able to special order most anything".

If you are near Knockan Crag in Assynt, Scotland, don't miss my favourite boulder – the Sphere.

As the name suggests it is a perfectly round rock balanced on a steep incline, looking as though it has been frozen in stop-motion as it was rolling downhill.

Braver souls than me like to be photographed under the giant stone ball, rather like the woman standing beneath the comparatively smaller and more stable boulder in the main photograph here.

Recently, renowned land artist Michael Heizer was commissioned by the Los Angeles Museum of Contemporary Art to transport a 340-ton granite rock to suspend over the entrance to the gallery.

Heizer discovered the perfect teardrop-shaped megalith in the Jurapa Valley east of Los Angeles, and brought it to town on a double-engine transporter, the length of three football fields, two-storeys high, 32ft wide, with 196 wheels and 44 axles.

Accompanied by twenty support vehicles and travelling at 8mph only at night, the journey took almost a month to arrive from the quarry.

Titled *Levitated Mass*, it has become a magnet for thousands each day to visit the museum, which until now had a limited appeal only for contemporary art aficionados.

They are clearly as bowled over by big boulders as I am.

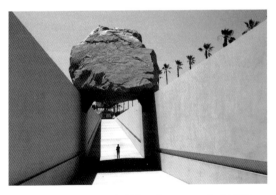

Levitated Mass sits atop a 456 ft long slot constructed at LACMA, allowing visitors to view the boulder installation from beneath. The bill for creating this artwork was $10 million.

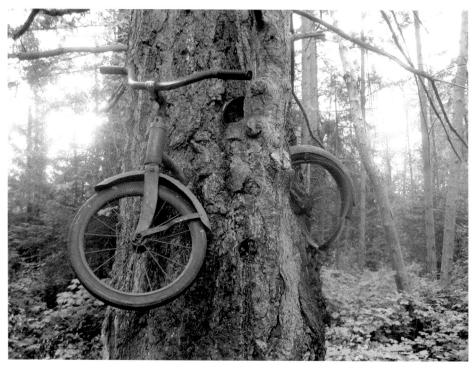

The Vashon Island 'Bike Tree'

The tree is a popular tourist destination on Vashon Island, in Puget Sound, Washington State. There are many stories about the bicycle tree, but the likelihood is that it's a sculpture or practical joke, erected sometime in the 1940s or 50s quite intentionally.

I relax by taking my bicycle apart and putting it together again.

Those are not my words. And I could have named more than 100,000 people who also didn't say it, and would never have alighted upon the person who did – Michelle Pfeiffer.

I have a friend who is as enthusiastic about bicycles as Ms Pfeiffer, and his mantra is simple: Work to eat. Eat to live. Live to bike. Bike to work.

The bicycle in the picture being partly consumed by a tree was believed to have been tied to a small sapling in 1914; the owner apparently never returned and the tree grew with the bike buried deep inside it, seven feet off the ground. But experts now claim it is a well-constructed prank, the spoilsports.

In 1770 Wolfgang von Kempelen built a chess-playing 'robot', named 'The Turk'. Originally conceived to captivate the Empress Marie Theresa, 'The Turk' gained fame as the Empress toured it around the courts of Europe.

It was believed to be a machine that could think, working through a series of mechanical cogs and crankshafts, but in reality it was a simple illusion.

A diminutive chess master was able to hide inside the small cabinet, and operate the pieces using magnets.

The Turk was celebrated in tours of Paris, London and America, where it won most of its matches against many highly regarded chess players, as well as defeating Napoleon Bonaparte and Benjamin Franklin.

The automaton inspired much debate and fascination, and many speculated that it was the resting place of a celestial spirit – a long dead chess grandmaster.

It continued to be exhibited for more than 80 years, long after von

Kempelen and one if its most famous operators, William Schlumberger had both died. Other gifted, but very small chess players were trained to operate The Turk on its tours. After being given to a museum, The Turk was destroyed in a fire, and finally its secrets were revealed.

Nonetheless, The Wolfgang von Kempelen Computing Science History Prize was named in his honour in Vienna. Although his most famous invention was 'The Turk', he also pioneered a steam turbine for mills, a typewriter for a blind concert pianist, a manually operated speaking machine, created the spectacular fountains at Schönbrunn in Vienna, and composed *Andromeda and Perseus*, widely performed in Austria.

For an aristocrat, Wolfgang appears to have been a delightful oddball; an expert in law, philosophy, mathematics and physics, he spoke several languages and was also a talented artist, and writer of well-regarded poems.

All in all, I think you would have found him an entertaining dining companion.

Had you ever heard about the Cardiff Giant?

In 1869 George Hull, a tobacconist in America, orchestrated one of the most widely accepted hoaxes in history. He hired a stonemason to create the figure of a 10ft giant out of gypsum, and had it buried in a cousin's farm in Cardiff, New York.

He waited a year, then employed some specialist builders to dig a well on the spot, knowing that they would discover the petrified man. When the giant was uncovered, it became a media sensation. Hull erected a tent around the dig site, and started a lucrative trade in selling tickets for 50 cents for a glimpse of the giant's body.

Though most scientists immediately condemned it as a fake after a cursory inspection, it continued to be such a draw that PT Barnum attempted to rent the giant for his circus. When his offers were rejected, he ordered a replica to be built, and started exhibiting it as the real thing.

Hull sued Barnum, but in the course of the trial it became clear that

both Cardiff Giants were frauds, and Hull finally confessed to creating, in his words, 'a whimsical innocent entertainment'.

A more serious forgery were the Niger Uranium Papers, which helped support the invasion of Iraq in 2003.

A series of documents were recovered by Italian military intelligence, providing evidence that Saddam Hussein was attempting to acquire Yellowcake Uranium from Niger. These were to become crucial evidence demonstrating that Iraq was building 'weapons of mass destruction', and were one of the foundations for the invasion by the U.S. and UK military.

After news of the papers leaked, the CIA investigated their authenticity and discovered they were fake.

Nobody has been charged with creating them, though obviously suspicion has fallen on members of the Italian and American intelligence communities; both bodies claim Saddam Hussein had many enemies who wanted Iraq destroyed, not an altogether flawless argument.

Turk, the chess grandmaster robot.

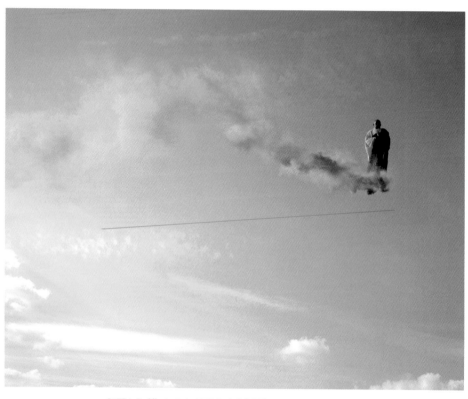

Li Wei, *Buddha in Paris*, 2012. Park de la Villette, Paris, 155 x 232.5 cm

Li Wei suspended himself from invisible wires attached to a crane to create the illusion of a flying monk. The artist never uses special effects in his work, relying on mirrors, scaffolding and perfect timing to capture his stunning photographs.

Everything that can be invented has been invented.

In May 2012 Gary Connery leapt 2,400 ft from a helicopter wearing a 'wing suit', flying for 55 seconds before plunging into 'runway' of cardboard boxes to ease his landing.

Connery, a 42-year-old stunt specialist, had studied the flight patterns of Kite birds and noted how they used their tails to control flight.

He had to obtain special permission from the Civil Aviation Authority for his endeavour, as his wings were simply nylon panels stretching from his wrist to his waist.

Hundreds of spectators watched anxiously as Mr Connery became the first skydiver to land safely without a parachute; his flight was filmed by a fellow diver who followed him out of the helicopter, but deployed his own parachute to land safely.

Flying has always been a wishful fantasy for most of us since childhood, and we all remember our excitement when first travelling on an aircraft.

But even aviation pioneer Wilbur Wright said in 1901, "Man will not fly for fifty years", after the failure of early inventions that he and his brother Orville created.

Two years later the Wright brothers recorded the first manned airplane flight ever made. Wilbur then confessed that, "Ever since my 'fifty year' comment, I have distrusted myself and avoided all predictions."

Wise advice, which a number of people could have heeded.

Thomas J. Watson, head of IBM in 1943 stated, "I think there is a world market for maybe five computers."

Even in 1977 Ken Olson, Chairman of Digital Equipment Corp., decided that, "There is no reason why anyone would want a computer in their home."

"You would make a ship sail against the winds and currents by lighting a bonfire under the deck… I have not time for such nonsense." This was Napoleon's assessment of Fulton's Steamship.

"The concept is interesting and well-formed, but in order to earn better than a 'C', the idea must be feasible." Fortunately Fred Smith ignored his Yale University professor's assessment of his paper proposing a reliable overnight delivery service. Smith went on to found Federal Express.

In 1949 *Popular Mechanics* magazine, in its forecast about the relentless march of science predicted, "Computers in the future may weigh no more than 1.5 tons."

Popular Science magazine in July 1924 foretold that, "Within the next few decades, automobiles will have folding wings that can be spread when on a straight stretch of road so that the machine can take the air."

Sir John Ericksen, doctor to Queen Victoria, said in 1873, "The abdomen, the chest and the brain will forever be shut from the intrusion of the wise and humane surgeon."

"Louis Pasteur's theory of germs is ridiculous fiction," wrote Pierre Pachet Professor of Physiology at Toulouse university, a year before pasteurisation was accepted as crucial.

"This 'telephone' idea has too many shortcomings to be seriously considered as a means of communication," said Western Union in 1876.

"The wireless music box has no imaginable commercial value – who would pay for a message sent to nobody in particular?"

This was the response to David Sarnoff when trying to secure investment in the radio during the 1920s.

"The aeroplane will never fly," said Lord Haldane, Minster of War in Britain in 1907, who obviously hadn't been advised about the Wright Brothers' successful breakthrough.

Harry Warner, founder of Warner Brothers said in 1927, as the silent movie was threatened by the introduction of sound, "Who in the hell wants to hear actors talk?"

Another Hollywood studio boss Darryl Zanuck, head of Twentieth Century Fox, said in 1946, "Television won't last because people will soon get tired of staring at a plywood box every night."

"Everything that can be invented has been invented," said Charles Holland Duell, Commissioner of U.S. Patents in 1899.

This rather echoes the thoughtful observation made by Frontinus in the 1st century AD, "Inventions reached their limit long ago, and I see no hope for further development."

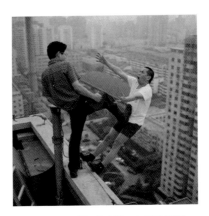

Li Wei, Live At The High Place 2, 2008.04.03,
Beijing, 176 x 216 cm

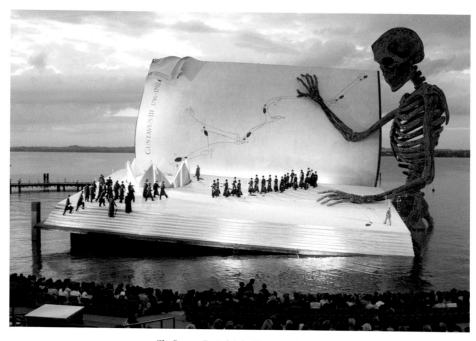

The Bregenz Festival, Lake Constance, Austria.

This is an image of the *Seebühne* (floating stage) set constructed for a run of Verdi's *The Masked Ball* in 1999-2000. The stage hosts elaborate opera productions that are famous for their extraordinary set designs, for audiences of up to 7,000. During the 2007 performance of *Tosca*, the producer and director for the James Bond film *Quantum of Solace* were so impressed, they filmed a 10-day scene in Bregenz where Bond meets his adversary for the first time during a performance of *Tosca*.

It's not just comedians who can die on stage.

However hesitant you may be about attending any theatrical production these days, however listless and predictable you may find the great morass of contemporary plays, arguably no other art form is as revealing of its time as theatre.

As the wheel of history turns theatre has suffered both rises and falls in fortune, allowing cynics to claim that today we get the theatre we deserve.

But rather I think, theatre appears to have lost its desire to be a vibrant life-force of cultural expression.

Producers seem to feel they can only fill seats with a merry-go-round of musicals, or revivals, and have forgotten that theatre thrived vigourously even after the onslaught of cinema and television.

Presently, theatreland seems to possess little ambition to raise the stakes.

Whether occupying a central role in society, as it did in Ancient Greece, or being banned outright under the restrictions of Puritanical rule, it has provided an anarchic release from the strictures of feudal control; enabled poetic expression of religious belief; and created a a focus for postmodern existential dismay. Unlike the present day, early theatre quickly became a vital part of people's lives, largely performed by travelling troupes, working on basic themes of comedy, tragedy, and tales of myths and gods.

It was regarded by many religions as dangerously pagan.

Surprisingly it was a woman who single-handedly resurrected theatre in Europe. Hrosvitha of Gandersheim, a canoness in Germany, wrote six plays on religious subjects, which were published in 1501.

Her plays were notable for radically transforming representations of women, showing them to be exemplary in their chasteness and perseverance, rather than weak and emotional creatures.

Another woman who had a widespread impact on the direction of theatre in Europe was Elizabeth I.

She simply banned religious plays, which had been the most popular form of theatre in the Middle Ages, but she greatly admired the secular plays of a burgeoning public theatre and supported them vigorously against the City of London authority's attempts to quash them as immoral.

It was during this Renaissance age for theatre that it became established as a pre-eminent art form, playing to audiences of aristocrats and peasants, and creating a platform for playwrights such as Shakespeare, Fletcher, Marlowe and Webster. The latter, John Webster, was famous for his gory tragedies such as the *The Duchess of Malfi* and *The White Devil*, in which much of the cast is stabbed, poisoned or unpleasantly murdered.

The blood lust of audiences has run through theatrical history since ancient times; that this is still the case today can be attested by the continuous run of a ghost story, *The Woman in Black*, since 1989, making it the second longest running play in the West End, after Agatha Christie's murder mystery *The Mousetrap*.

Most famous of all theatre-of-horror was the Grand Guignol, which opened its doors in Paris in 1897. The theatre occupied the site of a former chapel, and had only 293 seats, making it the smallest in the city.

Dripping with gothic detailing including confessional boxes (which provided amorous couples titillated by the onstage activity a degree of privacy), and gargoyled pillars and arches adding to the building's eeriness, it heightened the atmosphere of the gruesome plays staged there.

Paula Maxa was the theatre's most regular leading lady appearing in performances from 1917 to 1930, during which time she was murdered over 10,000 times, in at least 60 different ways, and raped at least 3,000 times.

Audiences were known to vomit and faint in the stalls in response to works like *Le Labatoire des Hallucinations* in which a doctor lobotomizes his wife's lover, before being brutally murdered by his zombie creation.

The Grand Guignol eventually closed after World War II, with the then

director Charles Nonon stating that the Holocaust had rendered its faux horrors obsolete. "We could never equal Buchenwald".

In modern theatre actors are notoriously superstitious. One of the great unexplained ground-rules of stagecraft is never to wish one another 'good luck'. Instead one would wish a colleague to 'break a leg'.

The origins for this are widely contested. Some believe that it stems from Ancient Greece, where audiences stamped their feet at the end of performances rather than clapped their hands; if the play had been particularly well received a spectator could have indeed broken a leg. French actors are slightly more direct and merely offer 'merde' as an ironic gesture of good fortune.

Theatre has claimed the lives of many. The hours are long, the pay poor, and rehearsing and performance schedules are gruelling; actors' superstitions probably grew as the history of theatre was peppered with instances of actual deaths on stage.

In recent years three actors have died playing a single role, Judas Iscariot. During performances in 1997, 2007 and 2012 the leads have accidentally hung themselves playing the penultimate suicide scene in *Judas*, their safety harnesses and vests having failed.

Tristan and Isolde is also a risky pursuit for performers. In 1911 Felix Mottl died whilst conducting the Wagner opera, and again in 1969 conductor Joseph Keilberth died in exactly the same moment in the score.

My favourite comedian Tommy Cooper died onstage during a performance at the Royal Variety show. Renowned for his magic act always going awry, many of the audience were unaware that when he collapsed to the floor it was not part of the routine; minutes passed before anyone went to his aid.

Eric Morecambe, another great British comic, suffered a fatal heart attack whilst on stage. What a cruel twist that earlier in his performance Morecambe had said to the audience that he would hate to die in as tragic a way as Tommy Cooper had.

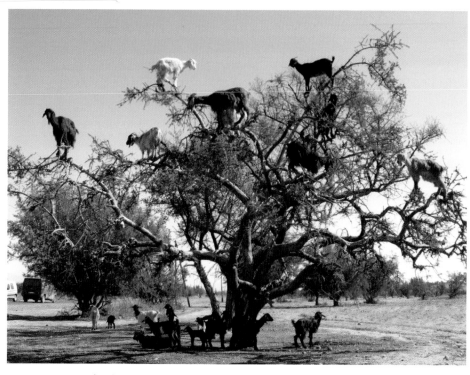

At first glance these incredible tree-climbing goats could be mistaken for very large, hairy birds. The goats have learnt to scale the Argan trees of Morocco in search of the black olive-like fruits the trees bare. The droppings of the goats contain the kernels of the seeds they consume which are used by locals to press and grind into oil, valued for its nutritive, cosmetic and numerous medicinal properties.

Burn your pashmina today.

The humble goat occupies a rather dark place in human cosmology. Reared as a domestic animal for its milk, meat, hide and dung since Neolithic times, they have since suffered the indignity of being associated with heresy, sorcery, Satan and lustfulness.

Thrown off belfries to celebrate saints' days, mutated in scientific experiments, chain-ganged and denuded to make pashminas for Sloanes, goats have had a hard time of it.

The sorry misrepresentation of the goat has a long history, starting in ancient times with the figure of Pan. Half-man, half-goat, Pan's parentage is a mystery, although most accounts concur that he was the son of Zeus. Handy in battle, his blood-curdling howl would strike fear into the hearts of the enemy, causing panic (a word that derived from his name).

His approach to women wasn't subtle, utilising a technique for courting nymphs by lecherously chasing them to the point of exhaustion and submission.

Apparently some nymphs were capable of morphing into a new form, as did the lovely Syrinx, who turned herself into large reeds.

Pan then callously fashioned them into the pan pipes that he is often portrayed with.

He did manage to lure Selene, goddess of the moon, down from the skies by hiding his black goat hair under a sheepskin. Quite why Selene was tempted down from her lofty perch by a stranger swathed in sheepskin is unclear, but reportedly, it was a full moon. She never returned for a second date.

Post Pan, in the 11th and 12th centuries, goats were central to the symbology of a dark and sinister figure – Baphomet. He rears his fearsome

goat head in transcripts of the inquisitions of the Knights Templar, a monastic group of knights whose prowess on the battlefield made them greatly feared during the Crusades.

They were eventually captured, tortured and burned at the stake for heresy due to their increasingly bizarre and depraved initiation rites. However it was also believed that their deaths were not unrelated to the fact that the King of France owed them a great deal of money.

Gradually the pentagrammed goat figure worshipped by the Knights Templar came to symbolize Satan himself, especially in the most feared tarot card illustrations, an inglorious association for goats in general.

Recently, goats have fared little better. In the tiny Spanish village of Manganeses de la Polvorosa, St Vincent's Day celebrations demand the young men of the village toss a goat from the top of the belfry, into a canvas sheet held aloft by villagers over 50 feet below. Once caught, it was lifted atop the shoulders of the crowd and paraded through the streets.

How this tradition started is something of a mystery; some suggest that St Vincent disturbed a goat who had climbed the belfry and it had fallen to the earth in surprise, but was miraculously unharmed. The contemporary goat population did not always recuperate well after the hurling exercise and in fact many died, prompting animal rights campaigners to successfully have the practice banned in 2002.

Around the turn of the century, Ches McCartney, became famous throughout America as 'The Goat Man'. He covered over 100,000 miles of the great North American landscape, scaling mountains during blizzards, and many miles of desert with a drove of goats pulling his wobbly cart.

A colourful, flamboyant man, an early sign of his eccentricity was his first marriage to a Spanish knife thrower ten years his senior he met en route. He became part of her act serving as the target she skilfully avoided hitting with her knives.

They eventually set up a farm that was wiped out during the

Depression, and the marriage broke up. Nature must have had a soft-spot for him because after he was badly injured in a tree-felling incident, and declared dead, he suddenly sprung into life again when the mortician plunged the embalming fluid needle into his arm.

Eventually McCartney decided that his calling was the open road once again, with goats and cart, a new wife, and young son, spreading the word of God.

If you are looking for a movie franchise concept to match the success of *Nightmare on Elm Street*, perhaps you could consider the Goatman of Maryland. According to urban myth, a scientist who worked at the local agricultural centre was conducting a series of experiments on goats when one of his trials went horribly wrong, leaving him alarmingly mutated.

Half-goat, half-man, he apparently still roams the streets of Beltsville, Maryland wielding an axe and attacking cars full of happy teenagers. Of course he could be just the scapegoat (sorry) for a local loony.

Pan watched over shepherds and their flocks, when he wasn't chasing maidens, attracted, he felt, to his magnificent goat horns and hindquarters.

Gate Tower Building, Fukushima-ku, Osaka, Japan

The 5th, 6th and 7th floors of this 16-storey office building are occupied by an express
highway passing right through the building, it is affectionately known as 'The Beehive'.
Aside from the intrusive highway, business at the Gate Tower Building is almost normal. The
highway does not make contact with the building, and a structure surrounding the highway
keeps noise and vibration out.

Let's hope Einstein was wrong for once.

Albert Einstein once pronounced that if "the bee disappeared off the face of the Earth, man would only have a few years to live".

Abnormally high death rates of bees in North America and Europe, varying from 30% to 70% of hives disappearing, are now of such urgent concern they have a name for the catastrophe: Colony Collapse Disorder.

In the UK half of honeybees in managed hives have gone, and wild bees are close to extinction.

Bees pollinate about a fifth of the food we eat, and 'hand pollination' now costs £1.8 billion in the UK alone to cover the service that bees provided for free.

Nobody really knows what is killing our bees.

Some experts believe that bees are ingesting pesticides from crops treated with insect nerve agents, after discovering that chemicals are present in nectar and pollen.

Others blame the loss of flowery meadows that feed wild bees across many parts of the globe as man is eroding further into the countryside to build homes and factories.

Specialists that have studied ghostly hives believe parasites and disease are killing the bees, as they succumb to mites, viruses, fungi and other pathogens.

Researchers have suggested that even low levels of pesticides are having a disastrous effect on bee colonies – the chemicals fog honeybees' brains, making it hard for them to find the way home.

This stops the supply chain of food to the hives, halting their ability to create new queens.

Bumblebees have been in severe decline in the US and the alarm has

fuelled biologists to determine that different species of flower attract foraging insects more effectively.

Their research shows a hundred-fold increase in the allure certain plants have for bees.

For example geranium species so popular with gardeners are not as popular with bees, and hardly visited, along with dahlias and other garden stalwarts.

Studies are desperately attempting to highlight the plants best able to provide food for the insect, so that they don't have to travel endlessly in late summer looking for suitable flowers.

But the mystery of vanishing bees continues, with even the growth of mobile phones being cited as a possible cause.

Furthermore, wasps are thriving, and they are a bee's most feared predator.

It's easy to understand Einstein's misgivings.

Bees have been around, producing honey, and pollinating our world for 30 million years; it remains the only insect that produces food eaten by mankind.

Bees have many gifts that make them superior to us in some impressive ways.

They can perceive movement separated by 1/300th of a second, whereas we can only sense movement separated by 1/50th of a second.

Were a bee to enter a cinema it would be able to differentiate each individual moving frame being projected.

The queen bee whose existence is now so precarious can lay 2,500 eggs per day. She will have mated just once in her two/three year life, and will mate with as many as 17 drones over a 24-hour period.

She saves the sperm so that she has a lifetime's supply and never mates again.

The male drones do no work at all, have no stinger, and all they do is mate.

Worker bees are sexually underdeveloped females and they only sting if they are threatened, dying once they have stung.

Rather charmingly, each honeybee colony has a unique odour for members' identification.

I was once probably like you, and flayed my arms around when a bee approached.

The more I learn about bees, the more I now welcome the sight of one, probably in some primeval fear that Einstein may have had a killing argument.

A natural beehive in the hollow of a tree.

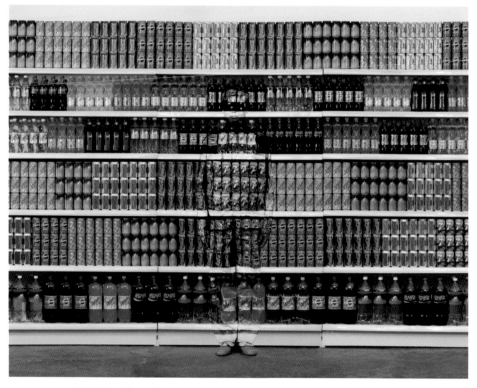

Liu Bolin, *Hiding in the City No. 93 – Supermarket No. 2*, 2010, Photograph, 118 x 150 cm

Liu uses a team of two assistants to paint the camouflage onto him to make him invisible.
Each photograph can take up to ten hours to set up. Sometimes the artist has his assistants
paint his body and then remains extremely still until an unsuspecting passerby happens to
walk past. He explained in 2010: "The inspiration behind my work was a sense of not fitting
in to modern society and was a silent protest against the persecution of artists... My work is a
kind of reminder, to remind people what the community we live in really looks like, and what
kind of problems exist."

Win or lose, we go shopping after the election.

These are the inspiring words of Imelda Marcos, widow of Philippine President Ferdinand Marcos.

She was celebrated for her collection of over one thousand pairs of shoes, and many women would agree with her that whoever said 'money can't buy happiness' simply didn't know where to go shopping.

Personally, I am always enthralled at the Chartres Cathedral-like majesty of a really enormous supermarket.

I can't really recall my first supermarket experience, because we used to think of Woolworths as supermarkets before we discovered what supermarkets really were.

Woolworths had long aisles of merchandise, with goods on display on elongated table tops, and sales assistants to pay, and to help you every few yards.

This was already a major breakthrough from the early days of retailing, where a product you requested was fetched by an assistant behind the merchant's counter, and customers stood in front and indicated the items they wanted.

Often, the items were not already pre-packed, so the assistant would measure up and wrap the precise amount required by the customer.

This offered opportunities for social exchanges, pause for conversation. Charming, but apparently very expensive for the retailer, because the number of customers who could be attended to was limited by the number of staff employed.

The concept of the self-service store was pioneered by entrepreneur Clarence Saunders and his Piggly Wiggly stores that started opening in America in 1916.

But historically, the first supermarket was King Kullen which opened in Queens, New York, in 1930. It operated under the slogan "Pile it high. Sell it low".

So although Saunders had introduced the world to self-service, uniform stores, and nationwide marketing for his branded outlets, King Kullen supermarkets added separate food departments, took advantage of bulk buying of stock to offer very advantageous pricing to customers, and added parking lots.

Other established grocery chains like Kroger and Safeway at first resisted King Kullen (whose founder Michael J.Cullen had been a former Kroger employee), but had to follow his model after the 1930s recession made customers more price- sensitive than ever before.

With the growth of automobile ownership and suburban development after World War II, supermarkets became a familiar sight in shopping centres.

But in Britain, even by 1947 there were just ten self-service shops in the country, and it took entrepreneurs to parcel up grocery chains across the country into single ownership, then take advantage of bulk-buying power, and start to build today's leading supermarket chains.

Nowadays supermarket management is highly scientific, and marketers will use well-researched techniques to influence purchasing behaviour. The first principle of store layout is circulation, with high-draw, high-impulse items on the paths to essential buys, influencing consumers to purchase something that was not on the shopping list. En route to necessity buys, power products with high margins for the retailer can catch the eye.

Certain products are carefully placed together in a complementary way to increase sales of both e.g. tea, coffee and biscuits adjacent.

High-draw products are placed in separate areas of the store to keep driving customers throughout the aisles, so bread and milk are often located at the rear of the store to increase the start of circulation.

Entrances are often on the left hand side because research has shown

consumers travelling in a clockwise direction spend more.

Fruit and vegetables are often placed at the front of the store to give the supermarket a fresh and healthy image.

As well as sight, the other two senses that retailers try to stimulate are sound and smell.

Researchers at Leicester University showed that French music played in a supermarket's wine aisle boosted sales of French drinks.

The following day, German folk music led to a surge in sales of German wines.

More recently, store chiefs have been tapping the potential of 'nebulisation technology' – when a fragranced oil is converted into a dry vapour and distributed through a shop by way of the air conditioning system.

Chemically generated odours can create smells of fresh shampoos near cleansing products, newly-baked dough near the bread aisles, scented aromas around the beauty counters.

In-store fragrance enhancements have been shown to increase intent to purchase by 80%; it plays such a crucial role because it is the sense directly connected to the parts of the brain responsible for processing emotions, delivering an immediate impact on behalf of the retailer.

The power of supermarkets is such that they can demand 'slotting fees' from manufacturers who want to feature their products in premium shelf space, or positioned at eye-level, or placed on the checkout aisle, or highlighted at a shelf's 'end cap'.

The only problem left for the experts in 'Shopper Manipulation in Supermarkets' is how to deal with consumers who feel so over-manipulated, they now shop online.

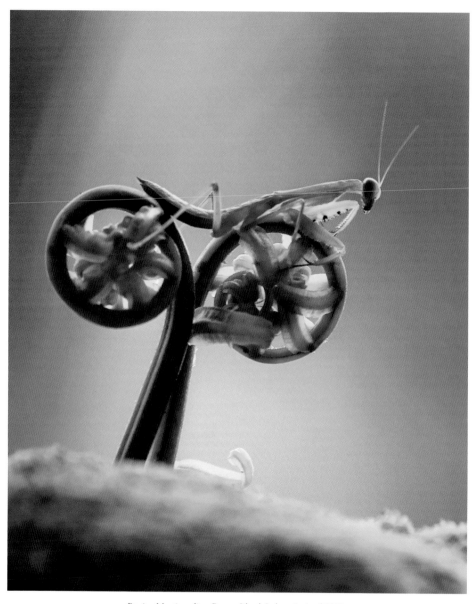

Praying Mantis cycling, Borneo Island, Indonesia, April 2012.

Amateur macro-photographer Eco Suparman was astonished when the praying mantis he was photographing jumped up onto a curled plant resulting in a shot that appeared to frame it mid-bicycle ride. These insects have spiked forelegs which they usually use to catch prey; however in this picture, the mantis appears to be using them to steer the bicycle.

If they can't see you, they can't eat you.

This is obviously the mantra that lay behind some of Darwin's thinking about natural selection. It explains why some of the hardiest species on the planet are those that can hide in plain sight; insects that can mimic a leaf, blending in to look just like one of thousands on a tree or a branch; those that can go a stage further, and look identical to a dead leaf lying on the ground.

The most subtle illusionists can make themselves look uncannily like a decomposing leaf.

The Flower Mantis is wily enough to prey on other insects by impersonating an orchid blossom.

Evolution obviously favoured creatures with the ability to evade detection both from those that would eat them, and from those whom they wish to eat.

As Darwin made clear it's not the strongest, or most intelligent of species that survive. It's the ones that are the most adaptable to change.

Contrary to popular belief, chameleons have the ability only to switch colour when in imminent danger. Their everyday skin colour of varying shades of khaki usually makes them hard to spot in the terrains they inhabit.

In human terms, we too have our chameleons.

Successful confidence tricksters through the ages have been able to adapt themselves into personas that help entrap their victims.

They rely on their ability to instil assurance, through their gift of appearing credible and persuasive, as much as they depend on their prey's greed. Every con artist's hero Charles Ponzi, the creator of the original pyramid scheme that bore his name.

Although he was eventually jailed, he had a long, colourful and prosperous life, paid for by the money he swindled from 'investors'. To many people in the early 20th century he was seen as a loveable rogue. But not to those whose life savings had helped build the pyramid before it crashed... with their cash.

Around the same time in Europe, World War I had left France in tatters, financially as well as physically. In this climate the maintenance of the Eiffel tower in Paris was considered by many to be a somewhat extraneous expense.

The dire fiscal environment spawned by war often lays bare the most cunning and pragmatic of tricksters, and so was the case with Victor Lustig, another of the great master craftsmen of the elaborate, audacious fraud.

Convincingly disguising himself as a municipal official influential in government circles, he convened a meeting with a group of scrap metal merchants and told them that due to prohibitive budgeting constraints, Parisian authorities were knocking down the Eiffel tower, and selling it off for scrap.

Whilst it may seem hard to comprehend how anyone could have been drawn in by this plot, it's worth remembering that Lustig's meeting took place just 18 years after the tower was supposed to have been dismantled, having only ever been intended as a temporary construction.

The brazen Mr Lustig took the dealers on a tour of the tower, and did eventually entice one of them into handing over the entire sum for all of the tower's metalwork.

Cash in hand, he bolted once word reached the police, but in an act of somewhat admirable audacity, returned to Paris a second time to try his luck with the same scam, and pulled it off once again.

The law eventually caught up with him and he eventually died in jail many years later of pneumonia.

Another rival to Lustig's exploits was American George Parker, who

profited quite splendidly by selling 'rights' to New York's famous landmarks to unsuspecting tourists.

His preferred monument to barter was the Brooklyn Bridge, which he sold twice a week for many years.

His scheme persuaded unwitting victims that they could rake in cash by controlling access to the roadway across the bridge. Ingenuous customers of Parker's had to be removed by police several times as they tried to erect toll barriers.

The gusto with which Parker went about his sales, setting up phony offices from where he handled the negotiations, was much admired in the mythology of the greatest tricksters. He is still revered in the world of the conman for posturing as General Grant's grandson, when he succeeded in selling control of visiting rights to the former U.S. president and military leader's tomb.

When Parker was finally jailed, he was the most popular inmate in the prison with both guards and convicts, who apparently greatly enjoyed hearing about his swindles, and the delightful gullibility of the poor souls trapped in his schemes.

This Dead Leaf Mantis is camouflaged to mimic decaying, crumpled leaves. If disturbed, they gently rock as if they have been caught in the breeze, and if they feel threatened, they will throw themselves to the ground, lying motionless on the floor.

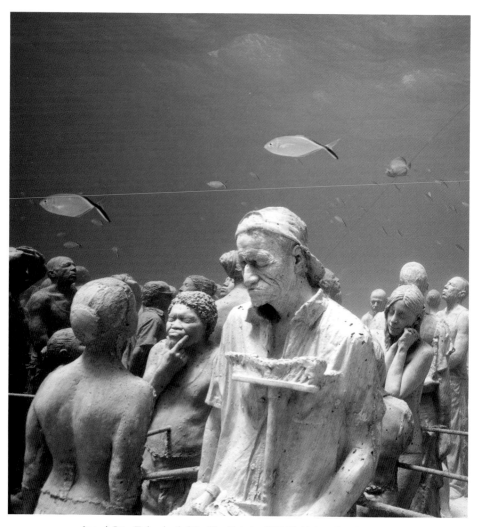

Jason deCaires Taylor, detail of *The Silent Evolution*, 2010, Isla Mujeres, Cancún, Mexico

The Silent Evolution is a permanent monumental artificial reef in Mexico. Occupying over 420sqm and with a total weight of over 200 tons, it consists of 400 life-size casts of individuals taken from a broad cross section of humanity and has been designed to aggregate fish and corals on a grand scale. The work is installed in the National Marine Park of Cancún and is the first endeavour of a new underwater museum called MUSA, or Museo Subacuático de Arte.

The mysteries of the deep grow deeper.

Ever since Plato first described the city of Atlantis, occupying a region beneath the seas as large as Libya, scholars have scoffed that such an advanced civilization has never been detected.

However, a wealth of human history has been recently discovered in our oceans, and technological innovations have led scientists to question theories accepted for decades, theories that are being undone with every new finding.

As an example, in the Bay of Cambay India, remains were discovered of a 9,500-year-old city, intact with its architecture and human skeletons, pre-dating by 5,000 years any knowledge of civilization in that area.

In Yonaguni-Jima, Japan, a diver discovered pyramids, carbon dated as thousands of years old, created off the coastline. The structures appear to have been carved out of bedrock in a terra-forming process using tools unavailable to cultures of the region.

A team of scientists continue to unravel megalithic ruins found in the Yukatan Channel near Cuba.

They have created computer models of a mysterious underwater city, showing an extensive urban environment stretching for miles along the ocean floor, with evidence of civilizations that pre-date all known Ancient cultures in that part of the world.

It may appear that we require the soundtrack of *Twilight Zone* to be playing in our heads as we read about Earth's unexplained mysteries; but aren't you rather invigorated by the knowledge that there are so many 'known unknowns' still to be discovered on Earth, even now?

Alarmingly, cities in the present day may fall victim to the same demise as Atlantis.

Cracks in the road at the foot of the Shanghai Tower Project – a 632m high structure due to be completed in 2014 – gave the citizens of Pudong cause for concern that the foundations of their city were shifting.

Shanghai has sunk 2.6 metres since 1921, with *Le Monde* reporting that a recent study by the Institute of Geology and Geophysics shows that "Fifty fast-expanding cities are affected by this type of subsidence, mainly as a result of the excessive use of groundwater. The rise in demand is due to people migrating to the cities, and to changing patterns of consumption and industrial growth."

The Colosseum in Rome is approximately 15.5 inches lower on its south side than on its north. It is thought that vibrations from busy roads and a metro line close to the famous landmark are to blame. Luckily, there is a $30 million restoration project getting underway in December, due for completion in 2014.

Venice has a very well documented sinking problem; its foundations resting on millions of wooden piles stacked into marshy ground have sunk by about seven centimetres a century for the past 1,000 years.

Venice is not alone. Other famous locations sinking lower each year are the island of Bora Bora, and the Taj Mahal.

Closer to home, this sinking feeling hasn't gone unnoticed by artists; Michael Pinsky has used lights on landmarks across the capital to show the predicted sea level of London in the year 3111, demonstrating how much would be submerged in 1,000 years time.

His artwork may appear a little bleak and pessimistic to some viewers, but particularly so to committed Global Warming deniers like me.

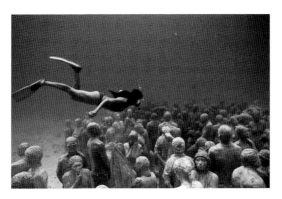

Jason deCaires Taylor is an eco-sculptor who creates underwater living sculptures. His site-specific, permanent installations change over time with the effects of their environment. These factors create a living aspect to the works, revealing the imperceptible changes of nature on human artifice. Taylor states, "It's environmental evolution, art intervention as growth, or a balancing of relationships."

A man stares up from the base of General Sherman, a giant sequoia tree located in the Giant Forest of Sequoia National Park in Tulare County, California. By volume, it is the largest known living single stem tree on Earth, with a height of 275ft, a diameter of 25ft, and an estimated age of 2,300 – 2,700 years. The tree was given its name in 1879 after American Civil War General, William Tecumseh Sherman, by naturalist James Wolverton, who had served as a lieutenant in the 9th Indiana Cavalry under Sherman.

Would you rather be honoured with a giant tree, or a postage stamp?

General Sherman served in the Union army during the American Civil War, and received recognition for his outstanding command of military strategy, as well as severe criticism for the harshness of the 'scorched earth' policy he implemented in order to bring the Confederate states to their knees.

He succeeded General Ulysses S. Grant as Union commander, capturing the city of Atlanta in a military coup that contributed to the success of the election of President Abraham Lincoln.

Sherman went on to take responsibility for a dark moment in U.S. history, when he led the U.S. army's engagement in the Indian Wars that lasted 15 years, largely destroying the population of many tribes.

He was fondly known as Uncle Billy Cump by his troops, but I haven't discovered why. His renowned response to the hardline approach he took to quashing any resistance from opposing armies during his career was, "You cannot quantify war in harsher terms than I will. War is cruelty, and you cannot refine it; those who brought war into our country deserve all the curses and maledictions a people can pour out."

But when comparing Sherman's scorched earth campaign to the actions of the British army during the Second Boer War, another battle where civilians were targeted because of their central role in sustaining an armed resistance, a leading South African historian noted, "It looks as if Sherman struck a better balance than the British commanders between severity and restraint in taking actions proportionate to legitimate needs."

Besides the giant tree named in his honour, he is the only military leader to have an image of his face on a stamp, and has featured on more U.S. postage than almost any U.S. President.

Sherman regularly appears on top ten lists of military commanders, alongside other revered leaders.

Georgy Zhukov led the Red Army in liberating the Soviet Union and advancing though much of Eastern Europe to conquer Berlin in 1945.

Attila the Hun was the leader of the Hunnic Empire which stretched from Central Asia to modern Germany.

He was the most feared enemy of the Roman Empire, who paid him off to leave them alone.

William the Conqueror led the Norman invasion of England, the last time we were successfully taken over by a foreign power.

Genghis Khan founded the Mongol Empire, the largest contiguous empire in history, by uniting the nomadic tribes and confederations in northeast Asia under his banner. He waged successful campaigns against powerful dynasties through his much admired military intelligence and tactics.

In terms of great leaders, it's hard to beat the Hannibals, the Bonapartes, the Caesars, the Alexanders of this world.

But they would all probably agree that the greatest of their kind was Cyrus the Great. He founded the Persian Empire, spanning three continents, but unlike others his empire endured long after his demise due to the political infrastructure he created.

He may not have had a postage stamp in his honour, but the world's most ambitious dictators, including Mao Zedong and Adolf Hitler all studied at his sandaled feet for inspiration.

Of course, even great generals make exceptionally poor military decisions occasionally.

Napoleon's invasion of Russia in June 1812 could only have been out of sheer boredom.

He had conquered most of Europe that had refused to ally with him, and his enormous army had little to occupy them. He took his 760,000 men and decided to invade Russia.

The Russians, as you know, simply retreated into the vastness of the country, burning everything in their wake.

When Napoleon arrived in Moscow, he was greeted by smoking ruins, and such a very harsh winter that his supply lines were cut. His soldiers either froze or starved to death, with only one in three returning.

Of course, invading Russia also ended up destroying Hitler's grand plan for *Lebensraum*, and his Operation Barbarossa was probably the clearest example of somebody failing to learn from history, and being doomed to repeat it.

But even the Russians weren't immune from foolhardy military expeditions.

Yuri Andropov decided to invade Afghanistan in December 1979, but found the Afghans a hardy bunch, expert in guerilla warfare and well-armed, via the United States, with Stinger missiles. They shot down 333 Soviet helicopters before the Russians gave up and went home.

What kind of naivety could have led our politicians to overlook Russia's ten-year failure to defeat Afghanistan, and believe they would succeed today?

The M4 Sherman was the primary tank used by the United States in World War II. Thousands were distributed to the Allies, and it followed the British practice of naming tanks after renowned generals.

Longaberger Headquarters, Newark, Ohio

The Longaberger Company is an American manufacturer of, amongst other home and lifestyle products, handcrafted maple wood baskets. The company's headquarters is a local landmark and a well-known example of novelty architecture, since it takes the shape of their biggest seller, the "Medium Market Basket".

The average woman's handbag weighs the same as five packs of sugar.

We all know that ladies' handbags are not used to just carry things.

They even moved beyond the realms of being a mere fashion accessory, after Louis Vuitton first introduced branded bags. They are now as desirable to women as jewellery, coveted enough to be the centrepiece of many a shopping spree.

I dare you to guess the most expensive handbag in the world.

It's the £2.35 million House of Mouawad purse, adorned with 4,356 colourless diamonds, 105 yellow diamonds and 56 pinks ones, 381 carats in total. Heart shaped and crafted in 18ct gold, each bag takes four months to complete, so they're creating something of a waiting list.

The Hermès Birkin bag is renowned as a desirable must-have for fashionable celebrities, but even they may baulk at the £1.75 million version, in platinum and diamonds. It even has a diamond strap, that some women argue makes the purchase very practical, as the strap can be detached and worn as a necklace, and the bag used as a clutch. Its versatility can be further demonstrated by the handiness of being able to detach its 8 carat pear-shaped centrepiece diamond to wear as a brooch.

Much more affordable is the Chanel 'Diamond Forever' bag at just £161,500, in alligator skin studded with diamonds set in white gold.

Lana Marks produces a bag at £154,650 that is seen carried by particularly discriminating visitors to the Academy Awards ceremony; its desirability is enhanced by the fact that only one bag is produced each year.

Obviously my favourite handbag was the black Asprey bag which epitomised the power of its owner Margaret Thatcher, when she met with other world leaders including Ronald Reagan and Mikhail Gorbachev. It

was in fact, a gift from Reagan, and was auctioned in 2012 for charity fetching £73,000.

Did you know that the average woman hauls around a handbag weighing over 5lbs on her arm, or shoulder? Apparently it's the rising number of beauty aids, laptops, mobile phones and chargers, address books, novels, keys, makeup bag, mirror, and often work shoes, that take a 1lb bag to the weight of a builder's hod, keeping chiropractors in business repairing aching backs.

As the prices of designer handbags has escalated, it is understandable that there is a surging market in counterfeit knock-offs available everywhere around the globe; fake Rolexes, fashions, electronics, DVDs, cigarettes, and medication now account for about 10% of world trade.

But the ever-reliable EU has pronounced that it is absolutely OK to buy fake designer goods.

They have determined, after a well-funded report, that buying knock-offs can benefit both consumers and the companies whose product designs and brand are being stolen.

They argue that people who buy fakes would never buy the real thing, and that the rip-offs provide the satisfaction of the authentic item.

They add that police should not waste their time trying to stop bootleggers, disputing claims that counterfeiting luxury goods is funding terrorism and organized crime.

Professor David Wall from the UK Home Office who co-authored the report explains: "There is evidence that it helps brands by quickening the fashion cycle, and raising fashion awareness." He adds, "I have just come back from Corfu and saw a Breitling watch being sold for £8. No one in their right mind would think that is a real Breitling watch." I wonder how Breitling and other leading manufacturers feel about his observations.

Let shopper Jacqueline Mardon, who collects limited edition Louis Vuitton bags, have the last word: "It's not about how much you spend, it's about the gorgeousness."

The basket handles weigh almost 150 tons and can be heated during cold weather to prevent ice damage. Originally, Dave Longaberger wanted all of the Longaberger buildings to be shaped like baskets, but only the headquarters was completed at the time of his death. After his death, further basket-shaped buildings were vetoed by his daughters.

The Green Lake sits at the foot of the Hochschwab mountains in Austria. It completely dries out in the winter but fills up again in the summer when the ice and snow on the mountaintops begins to melt, submerging roads, benches and trees, such as this one caught on camera by a scuba diver.

Adolf Hitler was not the only renowned Austrian.

It isn't merely underwater parks that make Austria outstanding in many number of ways. The list of famous Austrians is far easier to dredge up than the pop quiz favourite of identifying renowned Belgians.

I can name a prominent list of actors including Helmut Berger, Klaus Maria Brandauer, Maximilian Schell, Romy Schneider, Christoph Waltz and Oscar Werner. I hope you are too young to remember them all.

We recall Adolf Hitler quite well, and I am sure he would compare his skills to other Austrian painters like Gustav Klimt, Egon Schiele and Oskar Kokoschka, and architects like Alfred Loos and Richard Neutra.

Austria specialised in composers, and produced Bruckner, Handel, Mahler, Mozart, Schönberg, Schubert, and Strauss.

Some of my favourite filmmakers were Austrian: Billy Wilder, Fred Zimmermann, Erich Von Stroheim, Otto Preminger, and Fritz Lang, who all luckily escaped before Austria followed its favourite pastime of rounding up unwanted citizens.

Austria also grew an impressive army of psychiatrists and philosophers, though why I am linking the two, I may have to ask a shrink: Freud, Adler, Wittgenstein, Popper, Buber, Gomperz.

I'm not well acquainted with Austrian literature, and the poetry of Rainer Maria Rilke does very little for me.

Everyone's favourite Austrian would probably be Georg Ludwig von Trapp, whose family was immortalized in *The Sound of Music*.

You're too young to remember the Austrian Hollywood screen goddess Hedy Lamarr. She was a looker, but surprisingly to me, also the co-inventor of the breakthrough spread spectrum wireless communication system, whatever that may be.

In Austria, children at Christmas don't have everything as merry and fun-filled as those growing up here. St Nicholas (their version of Santa Claus) is accompanied on Christmas Eve by a mythical creature called the Krampus who warns and punishes bad children, in contrast to St Nicholas who hands out gifts to the good ones.

When the Krampus finds a particularly naughty child, it stuffs the terrified little one in its sack, carrying it off to its lair, to devour it for Christmas lunch.

High-spirited Austrian youths dress up as the Krampus during the week preceding Christmas, roaming the streets, carrying rusty chains and bells to scare as many infants as possible. The Krampus is featured on holiday greeting cards called Krampuskarten in a charming celebration of Bavarian folklore.

Perchta is a slightly more mellow alternative to Krampus. She traditionally appears in the twelve days leading up to Christmas Day, to pre-punish misbehaving children.

She doesn't carry you away to eat you. If you've been bad, she slits open your belly.

It's little wonder that so many Austrian children become musical prodigies, or psychiatrists.

Seasonal greeting cards featuring Krampus.

If you want to win an Oscar, go to Yale.

In 1906 Stanford University, one of the pillars of the Ivy League university system in the U.S., was rocked by a violent earthquake that destroyed many of its buildings. Despite the intensity of the quake and the fear it engendered, the event did have its moments of amusement, especially when a monumental statue of Louis Agassiz plunged from its plinth and landed head down, deep into the pavement.

Renowned as an eminent paleontologist, glaciologist, geologist and innovator in the study of natural history, after his dethroning on that fateful day one account recalled, "Agassiz's natural instinct when the earthquake came was to stick his head underground to find out what was going on in the earth below".

A rather more apt interpretation might be of Agassiz burying his head in the sand, given his avowed rejection of Darwin's evolutionary theories of creationism, and his own controversial advocation of polygenism – the theory that races come from separate origins and were endowed with unequal attributes. The debates stirred up by these latter beliefs have lead to landmarks, schoolhouses and other institutions being renamed to dissociate themselves from him.

Controversy is nothing new for the Ivy League; standing proudly at the heights of academic achievement in the USA, colleges like Brown, Columbia, Cornell, Dartmouth, Harvard, Princeton, Pennsylvania and Yale, have become international symbols of educational excellence, churning out Nobel and Pulitzer Prize winners, business leaders, senators and Supreme Court judges.

Yale alumni alone account not only for a number of America's Presidents, but also for many original thinkers including Dr Spock the

groundbreaking paediatrician; Bob Woodward the Watergate-breaking journalist; writer Tom Wolfe; and artist Mark Rothko.

More importantly to many, Yale has made a habit of turning out Academy Award winners. Oscars have been handed to Paul Newman, Meryl Streep, Oliver Stone, Jodie Foster, Edward Norton, Matt Damon and many others at the top of film, television and theatre.

This propensity to produce world leaders, academic paragons and cultural arbiters has led to Ivy League schools becoming the dream destination of students across the globe, and the focus for ambitious parents keen to see their offspring attend their own alma mater, or to pave a new path for familial accomplishment.

The largest financial and consulting firms tend to recruit from the campuses of the Ivy colleges, and with this prestige and clout come accusations of elitism and unfair advantage. But of all students who apply for the few coveted places, after the rigorous application processing, 90% will be unsuccessful in their efforts – often despite family wealth, prestige or connections they may be have been able to leverage.

Recent attempts to understand just what the entry boards are looking for have divined that only the following counts against applicants – the fact that the whole process is seemingly arbitrary.

The term Ivy League itself comes from the long revered walls of the older colleges being festooned with emerald ivy. The title came into usage to refer to intercollegiate athletic traditions.

The strange and impenetrable world of the Ivy League college has long fascinated people the world over.

Mystical Greek letters symbolising ancient sayings were used to name the first student fraternity, Phi Beta Kappa – "philosophy is the helmsman of life". Fraternities evoke strange 'hazing' rituals, casual misogyny, racism and elitist bullying.

Stories of alcohol related deaths and sexual assaults regularly tarnish the image of sororities and fraternities. The recent death of George Desdunes

during his hazing at Cornell as an initiation to Sigma Alpha Epsilon shocked many; as part of the ritual he was 'kidnapped' and force fed alcohol and drugs, later to be found dying on a sofa.

Hazing at Princeton has been reported to involve being disrobed naked on stage by a stripper and whipped severely in front of 40 other 'pledges'.

More innocent hazing sessions for those seeking entrance to Epsilon Pi involved having to crawl naked around the Mathey courtyard and pretend to be cows.

But Cornell remains the home of hazing, accounting for half of the initiation deaths in the Ivy League.

The popular representation of the sororities and fraternities that typify the Ivy League experience overlook one key factor – that many of these were founded in order to promote philanthropy and unity amongst students.

Whatever the motivation, and the outcome, the internal dynamics of 'frat life' have provided fodder for filmmakers for years.

From the legendary *National Lampoon's Animal House*, to *Legally Blonde*, the Ivy League college has become a film genre all of its own, portraying the sticky processes of coming of age.

Hazing tragedies, and the small community claustrophobia of campus life has contributed to colleges providing the perfect backdrop for slasher movies, such as *Scream, Murder on Campus, Killer Party* and *Ring of Terror*. Further film folklore holds that the mansion in *The Addams Family* is based on College Hall at the University of Pennsylvania.

The reputation, the power and wealth of the Ivy League is beyond doubt. In 2010, Harvard reported the largest endowments of any institution in the world at $27.4 billion, with 80% of its funding provided by the state.

With these huge cash reserves providing postgraduate students with financial support, and faculty staff with resources, tenure and better pay, there is little mystery why the brain drain of academics from the UK to the USA is so pronounced.

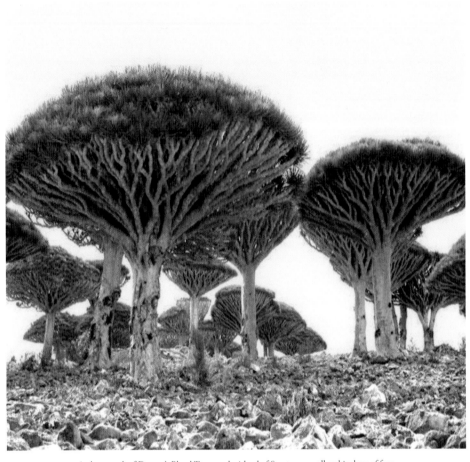

A photograph of Dragon's Blood Trees on the island of Socotra, a small archipelago of four islands in the Indian Ocean. The islands are small, isolated and their climate is very hot and dry which has resulted in their possessing a unique set of flora. The evergreen species is named for its dark red resin, known as "dragon's blood", a substance which has been highly prized since ancient times.

Slay a dragon before breakfast.

I must remember to send this picture of Dragon's Blood Trees to a gentleman in America.

Michael Hyatt is a motivational specialist who writes helpfully about how he faces his own personal dragon, Lethargy, each morning… and how he gets the better of it in three ways:

1. He reads the Bible. 2. He engages in exercise. 3. He listens to audio books.

The other useful piece of wisdom he passes on is that he uses his daily 40 minute commute by car as a good time to pray, referring to his automobile as his "prayer closet".

Mr Hyatt has written a *New York Times* bestseller, and lives in Franklin, Tennessee should you care to drop in for a personal consultation; he could perhaps help you to overcome any of your own dragons that are proving troublesome.

Dragonslayers have been popular heroes in traditional folklore; battling a ferocious, winged, fire-breathing creature was a handy way for a bold young man to demonstrate to the village his valour and fighting prowess, saving the comely local maiden from the distressing clutches of the fearsome beast.

The mythology grew out of the tales of *Beowulf* in the Anglo Saxon epic poem from about 800AD, in which after having defeated both the monster Grendel, and his fearsome mother, the protagonist then has to go on to confront an all-powerful dragon. He overcomes it but is slain himself in the process. However, he is buried alongside the dragon's treasure to keep its curse secure for all time.

Throughout history, across all areas of the globe, dragons have occupied

a central role in popular folktale, even transcending many faiths.

Broadly speaking, these mythical beasts have formulated independently through European and Chinese culture, and the different results are telling.

The dragon of the East is a powerful, magnificent and beautiful creature, whose symbol adorns clothing, palaces, paintings and objects of art.

As mythical beings, they stand at the apogee of Chinese tradition, representing primal forces such as nature, religion and the universe. They are associated with wisdom, and with their many magical powers are often allied with rainfall, hurricanes and floods.

There is a constellation of particular dragons stemming from ancient times in Chinese culture: Bashe is a flying dragon who eats elephants; Shen creates mirages; Tinalong pulls divine chariots; and Zhulong creates day and night by opening and closing its eyes.

As the highest-ranking creature in the animal hierarchy they are also traditionally linked to the Emperor and have become so synonymous with China globally, that many refer to the nation as 'the dragon' – a title that fits with its current economic might.

Those born in the years 1952, 1964, 1976, 1988, 2000 and 2012 are lucky enough to be born under the sign of the dragon in the Chinese Zodiac, and are to be honoured and respected by us all. They are typically energetic, ambitious, and successful. Unfortunates like me were born in the year of the Rat.

Dragons in Europe have had a harder time of it. Following on from *Beowulf,* in Norse mythology the heroic Sigurd killed a dragon that was guarding a massive haul of gold; he built a camouflaged pit, waited for the dragon to step on it and thrust his sword up through its vulnerable belly button.

Once slain, he bathed in its blood which rendered him invulnerable. Possibly, you and I would have been too fastidious to partake in the literal

blood bath, and would have carried on as vulnerable as ever.

St George is probably our best known slayer of dragons, and indeed was also an admirable evangelist, using the kill to draw people into Christianity.

Having saved a princess from its lair, he leads the dragon into town and promises to slay it if all citizens become Christian; they quickly agreed, as the dragon's roar, and fiery breath filled the main square.

There are very few accounts of women defeating dragons; routinely they tended to be bait or victims.

The story of St Margaret documents how one woman managed the feat, albeit in a rather passive way. This devout young lady was courted by the disreputable local Roman Governor, who demanded she renounce her faith in order to become his wife.

Her pious refusal led to her being cruelly tortured, with one torment including being swallowed whole by Satan in the shape of a dragon. She escaped from this ignoble end when the cross she carried irritated the dragon's stomach, causing him to rather wisely spit her back out.

A dragon slayer who let pride come before a fall was Heinrich von Winkelried, a knight reputed to have lived in Switzerland in the 13th century. He valiantly saved the village of Wilen from a particularly unpleasant dragon who had been liberally gobbling-up livestock and villagers.

Winkelried finished off the dragon with a barbed spear, but unfortunately waved the bloody weapon over his head in triumph; drops of dragon blood ran down its shaft poisoning the unlucky knight, who died a grisly death days later.

Popular mythology is ambiguous about the effects of dragon's blood. Some reports claimed that it has the power to render skin or armour bathed in it invincible, as evidenced in the tale of Sigurd.

In *Beowulf*, dragon's blood is reported to be highly acidic, and able to seep through iron.

Slavic myths hold that Mother Earth is so repulsed by the blood of a dragon that it never seeps into the ground, remaining instead on the surface for eternity.

One peculiar source of dragon's blood which is rather more readily accessible than from the mythical creature's themselves, are the Dragon Blood Trees. These unique forests grow native only on the isolated Socotra archipelago in the Indian Ocean, an island so remote that a third of all its plant life can be found nowhere else on the planet.

The tree is so named due to the red sap that it 'bleeds' from its berry-like fruit. Discovered by the dashing East India Company in 1835, although presumably in existence for millennia before this event, it has been used for many purposes since.

The sap was highly prized in the ancient world when it was used as a dye, medicine, breath freshener and lipstick. More prosaically, it was used as part of ritual magic and alchemy for luck, love and protection charms.

The origins of the myth of dragons is widely debated, but one theory is that there have been persistent mistranslations of real creatures into mythical ones.

For instance, tales of the Nile Crocodile may have reached further aboard than Egypt, after the Roman Empire investigated North Africa. Reports of the beast would have been elaborated in each re-telling.

Over the years, I can only imagine how the description of a crocodile had grown in size, spectacle and ferocious powers.

St George was a Greek who became an officer in the
Roman Army in about AD 300. He is a Patron Saint
in many parts of the world besides Britain,
including Georgia (the monument above is in
Tbilisi), Egypt, Romania, Ethiopia, Greece, Iran,
Portugal and Russia. Early Eastern Orthodox
depictions of St George slaying a dragon became
interpreted across the ages through Byzantium
iconography, and images bought back by Crusaders.

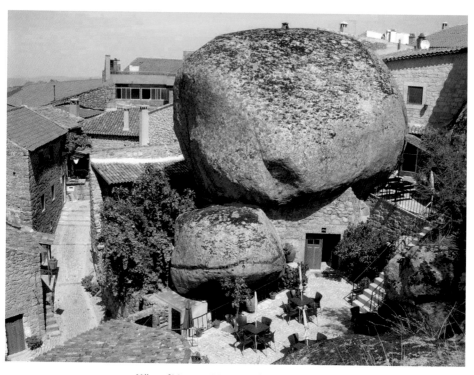

Village of Monsanto, Mountains of Monsanto, Portugal

The ancient people of Monsanto didn't hack through the rocks to build their homes; instead the granite houses were built around the natural shapes of the boulders. The region was first populated in the 6th century BC by the Lusitanians as a walled settlement. In 1938 Monsanto was voted "the most Portuguese village in Portugal" in a national contest, and since then building restrictions have allowed it to remain a living museum.

We should never have taught Portugal how to play football.

Portugal, a country many now associate with holiday homes, beaches, Nelly Furtado, Paula Rego, Cristiano Ronaldo and Jose Mourinho, has a vivid history stretching back to Neolithic times.

Taking its name from its second largest city, Porto, the country was conquered and occupied by the Moors in the 8th century. They were eventually driven out by the Knights Templar, a group of mystical warriors engaged as Crusaders and credited with turning the tables in the war between Christianity and Islam.

After the great Reconquista, Portugal officially declared itself an independent sovereign nation in 1139 – fuelling its claim to be the oldest European state.

The Portuguese continued this trend of doing things first, developing navigational and sailing technologies that heralded the Age of Discovery, discovering many places that didn't feel they needed discovering particularly, and certainly not being conquered.

This golden period of Portuguese prosperity was motivated by ambitious monarchs, and the development of cartography and the caravel, a sailing boat that allowed sailors to ride closer to the wind than they ever had before.

From 1491 onwards the Portuguese began to explore the coast of West Africa, seeking to find a lucrative route to the spice trades of Asia.

The psychological bravery needed to sail past the edge of their known world, Cape Bojador in the Western Sahara, is inestimable. Sea captains simply didn't know what lay beyond this point, and whether once sailed past, there was a way back.

The mental barrier was further enforced by many doomed earlier

attempts of sailors who succumbed to the violent storms that typified the area, provoking rumors of sea monsters.

Under the orders of Prince Henry the Navigator, a successful voyage past this point was made in 1434 by the mariner Gil Eanes.

The importance of this moment in the establishment of the Portuguese Empire is emphasized by the poet Fernando Pessoa, who in a long poem declared "Who wants to pass beyond Bojador, must also pass beyond pain".

The loss of seamen and explorers during this time may provide the etymological roots for their word 'saudade'. With no equivalent in the English language, saudade refers to a deep emotional state of nostalgic longing for an absent something or someone that one loves, often carrying a repressed knowledge that the object of longing will never return.

The wistful and romantic origins of saudade seems to hint at something intrinsic to Portuguese culture, exemplified both by the large number of poets in the Portuguese language, and the unusual but affecting story of Peter I and his lover, Inês de Castro.

Peter I was to became King in 1357. His wife, Constance of Castile, travelled to Portugal in 1340 to marry him.

With her was her handmaiden Inês, with whom Peter fell desperately in love. They began the affair that resulted in her bearing his illegitimate children. Constance died in 1345, and Peter's father Alfonso, alarmed by Peter's intention to marry the lowly Inês, ordered the lovers to be parted.

When this did little to assuage their love he ordered her to be killed, and she was beheaded at a monastery in front of her children.

Enraged, Peter found two of the killers and had them publicly executed, personally tearing out their still beating hearts. Once he had ascended the throne he had Inês's body exhumed, and declaring that they had married in secret before she died, anointed her Queen and forced every courtier to kiss the corpse's hand.

Peculiar tales seemingly abound in Portugal, and in 1917 one of the

strangest took place near the town of Fatima.

Called The Miracle of the Sun, over 30,000 people had gathered at a spot that three young shepherd children had predicted the Blessed Virgin Mary would appear that noon.

According to many witnesses, after a period of rain the sun suddenly appeared as a shining disc, danced throughout the sky, and neared earth to the point where some panicked that it was the end of days.

Many reported that the heat was now so intense that it evaporated deep puddles instantly.

What is remarkable about this event was that it was recorded by so many, including the leading intellectuals of the day, many of whom were sceptics and non-believers.

Attempts to explain it scientifically have suggested mass hysteria, mass hallucination, the diffraction of light through a myriad of dusts, or a diffusion of ice crystals.

The successes of the Portuguese colonization programme brought it to the heights of wealth, establishing itself as the first global Empire since Rome that spanned almost six centuries.

In 1498 Vasco da Gama reached India, founding the colony around Goa.

In 1500 Pedero Alvares Cabral discovered Brazil.

By 1571 a string of outposts connected Lisbon to Nagasaki along the coasts of Africa, the Middle East, India and Asia, creating a bustling trade, filling the coffers of the Portuguese monarchy.

The decline of the Empire was brought about by an ill-advised treaty with the Spanish, which although ensuring that there were no Spanish attacks on Portuguese colonies, also encouraged those enemies of Spain, such as the Dutch, English and French, to attack Portuguese held lands.

With a much smaller population, this heralded the collapse of the Portuguese Empire. This seems fitting today when we consider the number of slaves Portugal traded internationally.

Despite the eventual failure of the Empire it did succeed in establishing Portuguese as one of the most broadly spoken languages in the world. Including Brazil, there are 191 million Portuguese speakers around the world.

Relations with enemies such as the English improved once Portugal was no longer seen as a powerful threat.

Football, our most popular sport, was imported to Portugal by returning students from England in the final decades of the 19th century.

Guilherme Pinto Basto organised Portugal's first important football match in 1888, with a team of Englishmen vs. the locals.

The outcome now appears utterly predictable. Despite the advantages the English clearly should have held, having invented the game itself, Portugal won 1-0.

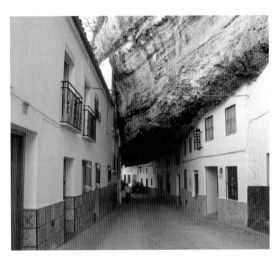

Setenil de las Bodegas, Cádiz, Spain

Setenil de las Bodegas, about 18 km away from Ronda in the province of
Cadiz, grew out of a network of caves in the cliffs above the Rio Trejo.
The old houses are built under the cliff overhang and the newer ones
against the hillside. Other than being built into the rock, Setenil is also
one of the typical Pueblos Blancos (White Villages) of Andalucia, that try
to stay as cool as possible in this hottest region of Spain by whitewashing
their houses every year, as white reflects sunlight best.

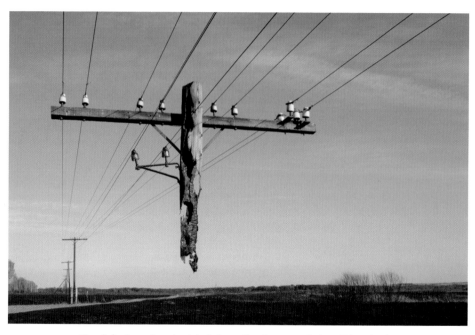

Never before has a telegraph pole looked more like what it is – a dead tree. Telegraph poles
have a life expectancy of decades after they've been dipped in creosote and often you'll see
men at the foot of these poles recoating them to give them a new lease of life. It looks like this
one got missed out and normal weathering has rotted it – not that that has prevented the
pole's good end from functioning as a conveyor of power.

Nobody ignores a telegram.

This was the slogan used for many years by Western Union, the world's first telegraph organisation.

It resonated well, because it happened to be true. It was inconceivable at the time that anything as revolutionary would one day be utterly redundant.

With the words, "What hath God wrought?" Samuel Morse initiated a 150-year reign of the telegram as the pre-eminent mode of global communication.

The invention was as seismic for the Victorian world as the contemporary invention of the internet; we can read the recent history of human development as the history of the ascendency of telecommunications.

Exponential growth in technology, cultural exchange and world diplomacy is aided and abetted by the development of ever greater and faster methods of communication.

From the invention of speech, to the use of smoke signals, from telegraphs, to the fax, to the internet, the ways in which we communicate fundamentally shapes both our subjectivity and perception of the world.

With the explosive creation of the transatlantic telegraph in 1866 the world became minute, with even its furthest reaches accessible for communication.

The rapidity of the development of these technologies was electrifying indeed. The culmination of all this – from that first transatlantic telegraph in 1866, to the invention of the telephone in the 1870s, to the widespread installation of telephone exchanges across America in the 1880s – was the first call from the UK to the U.S. made in 1927.

It was approximately 200,000 years ago that humans began to

communicate through speech. Symbols emerged as a method of communication relatively recently, around 30,000 years ago, stemming from the mnemonic function of cave paintings, to the highly developed pictogram writing seen in Egyptian hieroglyphs.

The first writing systems became evident around 7,000 years ago, contemporary to the first stages of the Bronze Age. The first pure alphabets emerged around 2000BC in Ancient Egypt, where 22 hieroglyphs were used to represent syllables.

The telecommunication race really started in earnest with the French engineer Claude Chappe, who built the first visual telegraphy or semaphore system between Lille and Paris.

This used a system of rods mounted on a spinning frame which could communicate 196 combinations of code. It was first used to inform Parisians of the capture of Conde-sur-l'Escaut from the Austrians less than an hour after it occurred, and the excitement it created amongst French society is reflected by the fact that the system was an intrinsic plot device in Alexandre Dumas' epic novel *The Count of Monte Christo*.

Semaphore systems remained slow and reliant on expensive towers, and were to be replaced with the advent of electricity, at first by complicated means involving bundles of wires, jars of acids and streams of hydrogen bubbles activated by currents.

It was with Samuel Morse back in 1838 that the telegraph, with its famous ticker tape, was demonstrated successfully over a distance of three miles. By 1851 over 20,000 miles of telegraph lines spanned the United States.

In 1858 a cable was run from Valentia Island in western Ireland, to Heart's Content in eastern Newfoundland, reducing the time it took to communicate between the U.S. and the UK from ten days – the length of time it took to deliver a message by ship – to a matter of minutes.

The first official telegram between the two continents was a letter of congratulation from Queen Victoria to the President of the United States,

James Buchanan. It took 16 hours to decode the Queen's 18-word message.

The technology soon improved and usage of telegrams became widespread across America and Europe; chillingly the start of World War I was heralded by telegraph.

As a telegram charged customers by each word used, people were economic with language in a way that echoes the current trend for Twitter's succinct messages.

In February 2006 Western Union closed the service, ending a 150-year era of the telegram. Since the American Civil War the company had been responsible for many thousands of messages, employing over 14,000 couriers on bicycle and foot at one time.

In 1982 the Internet Protocol Suite was introduced, and by 1995 this system was able to carry commercial traffic, and the internet as we know it today was born. Instant communication, enabling social networking, blogs, discussion forums, news, video calls and online shopping has clearly been revolutionary, and accelerated processes of globalization.

In 2012, 25% of the Earth's population surf the internet on a regular basis. Satellite technology has also profoundly affected telephones; there are over 6 billion mobile phones on the planet, owned by 87% of the world's population. Online technologies are now so powerful that in 2010 astronaut T. J. Creamer was able to post the first update to his Twitter account from the International Space Station.

Fibre optic cables are the veins of the internet, transferring data around the globe beneath the oceans. In the coming years, a 9,693-mile cable will be laid via the Canadian Arctic between the UK and Japan, shaving 62 milliseconds off the present speed between London and Tokyo, and lying 1,968 feet below the ice in order to avoid icebergs and other hazards.

But early in 2012 a ship in Kenya managed to sever a major undersea cable to East Africa with its anchor – proof of the surprising vulnerability of a system upon which we have all come to rely.

Last year it is estimated that more than 1.8 trillion gigabytes of information was created in an intense race between our ability to create information and our ability to store it.

There are now three million data centres of varying sizes worldwide and Samuel Morse's words seem ever more apt. "What hath God wrought?"

Samuel Finley Breese Morse 1791-1872 was a
professional artist, before he got round to inventing
both the electric telegraph and the Morse Code.

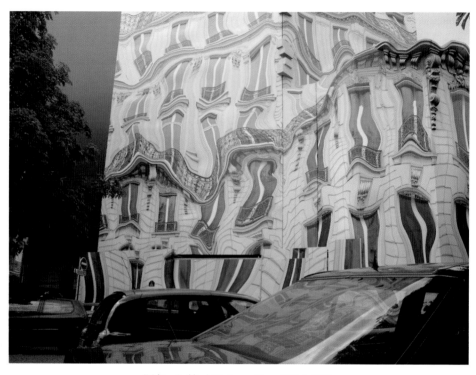

'Melting Building', 39, Avenue George V, Paris, 2007

This surreal façade was painted on tarpaulin to hide an otherwise ugly construction site from the eyes of the passersby. Building work was completed, and the spot is now home to a posh restaurant.

I don't love Paris.

Paris, the city of lovers, is famed internationally for its beauty, romance, nightlife and delicious food.

This attractive constellation has led to Paris becoming the most visited capital in the world, attracting over 30 million annually to sights as legendary as the Eiffel Tower, the Louvre and the Pompidou Centre.

The city is however Janus-faced, its high romance underpinned by a dark and bloody history, the memory of which is preserved through various sites, buildings and statuary.

After the ancient Parisii Celtic tribe were conquered by the Romans, the city was later typified in medieval times by vicious slums and rapacious plagues; the Black Death in particular killed as many as 800 people a day in 1348.

It was during this time that the infamous mines of Paris were first dug.

Many minerals lay buried in the Paris basin including limestone, sand, clay and gypsum; the origin of the famous plaster of Paris.

From the Left Bank to the Luxembourg Gardens, Montmartre to Belleville, long and deep tunnels criss-cross the foundations of the city.

Buildings in Paris tend to be only a few storeys high; the mines below prevent the foundations from being able to sink sufficiently low, and are less able to support their weight. Indeed there have been disasters such as that in 1774 when about 150-foot of street collapsed deep into a subterranean mine. There are over 400 miles of tunnels beneath Paris's streets. Intrepid urban explorers have been know to enter them, a real folly given the darkness, the need to crawl through some lengthy sections, and the difficulty of negotiating the labyrinthine network of unmapped mine shafts. A number have never emerged.

Victor Hugo used his knowledge of the mines and catacombs in his novel, *Les Misérables*, and during World War II Parisian members of the French Resistance used the tunnel systems to get about the city, usually hiding from other Frenchmen who had blithely accepted Nazi occupation; the French Vichy government made energetic collaborators, cheerfully doing the German army's work.

The mines came into their own in 1786 when measures had to be taken by authorities attempting to deal with the unsanitary conditions created by the overcrowding of cemeteries across Paris. Graveyards near churches had long become filled to capacity, to the point where bodies that had fully decomposed were dug up, their bones housed in charniers, and the space re-used for burying new corpses.

Considering Paris was a city reliant on wells bored into the ground for water, the implications of human body matter leeching into the soil were deeply unpleasant. Their solution: use the networks of mines as catacombs.

These were consecrated, and workers toiled through the night to transfer bodies to the tunnel networks.

Louis-Étienne Héricart de Thury, who took over the process in 1810, turned this solution into a work of art, overseeing renovations that would turn the catacombs into sepulchres.

Bones were used to festoon the walls, femurs created heart shapes, and skulls were employed as dado rails. Tourists are now able to visit these macabre halls, walking through a portal bearing the inscription "Halt! This is the Empire of Death". There is always a long expectant queue at the entrance.

Paris of course provided the centre stage for the French Revolution, with the storming of the Bastille in 1789 and the overthrow of the monarchy in 1792.

During the Reign of Terror, from 1793-1794, 40,000 people were killed. The scar of this terrible history still haunts the centre of Paris; the

Place de la Concorde was adopted during the Revolution and became the Place de la République, the home of the public guillotine. The guillotine had to be moved eventually because the ground around it had become so soaked in blood – that of the aristocrats and others found guilty by the courts, including Louis XVI and Marie Antoinette.

Tourists with a taste for the ghoulish also enjoy the Musée Fragonard d'Alfort. Located in the one of the world's oldest veterinary schools, it shows off its collection of monstrosities and anatomical oddities. Objects on display include Siamese twin lambs, a two-headed calf, a 10-legged sheep and a colt with one immense eye.

One artist well represented is their Professor of Anatomy in the 18th century, Honoré Fragonard (not to be confused with his cousin, a revered painter) whose prepared cadavers stand proudly throughout the building. His speciality was the preparation of skinned animals and humans, which he then arranged in tasteful poses. His *Horsemen of the Apocalypse* is based on the Dürer print and consists of a flayed man seated astride a horse, surrounded by small human foetuses riding sheep.

It may well be sights such as the catacombs and anatomical grotesques at the Musée Fragonard d'Alfort that have contributed to a recent phenomenon amongst Japanese tourists, the 'Paris Syndrome'.

Around a million Japanese travel to France every year, drawn by its history, beauty and atmosphere.

For many, what they encounter is entirely antithetical to the expectations they have built up.

Surly waiters, unnegotiable traffic, a plague of pickpockets, disappointing mid-priced cuisine, unhelpful locals and many unappetising tourist 'attractions' can be too distressing for those used to the serene and polite society in much of Japan.

The shock has caused psychiatric breakdown in some cases.

The Japanese Embassy has had to repatriate a number of visitors, with a doctor or nurse accompanying them on the flight home to help them get

over the trauma.

What is it about the Parisians that makes them so pompous, so arrogant, so superior, so unappealing?

The obvious, I'm afraid. They are insecure on too many levels.

They no longer inhabit the cultural centre of the world, nor indeed Europe; they make baleful contemporary art, sentimental and kitsch, never having quite recovered from the now overwhelming dominance of American art – Abstract Expressionism in the 1950s, American Pop Art in the 1960s, American Minimal Art that followed.

You can count the number of decent current French artists on one hand, and the number of interesting modern French writers on the other.

The Louvre is majestic of course, but the Musée d'Orsay, which now houses so many of France's masterpieces, presents them poorly, too cramped and ill-lit.

Their attempts at Manhattan-style skyscrapers in their business centre on the outskirts are embarrassingly hideous.

Parisian fashion no longer commands. As for their pop music...

The French may be difficult, perhaps because they are all a little undone at failing to live up to De Gaulle's dream that much of the world would by now be speaking French, and that France would be dominating world affairs.

More importantly to me however, France still makes magnificent films; cracking thrillers like *Engrenages* (*Spiral*, to me), the new *Point Blank*, *Anything for Her*, *The Beat my Heart Skipped*, *A Prophet*.

Four of my favourite recent film comedies have been French: *Dîner de Cons*, *Heartbreaker*, *Priceless* and *Intouchables*.

Perhaps it's simply that the French are better at a distance, and subtitled.

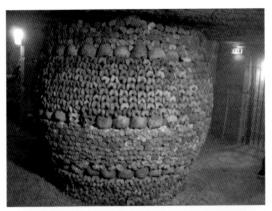

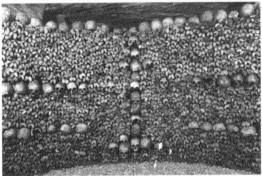

For three Euros you can stroll the catacombs of Paris, 2 km of tunnels artistically lined with the skulls of six million Parisians.It gets 4 stars from tourists in leading travel guide Tripadvisor.com.

Baldwin Street, Dunedin, New Zealand

Baldwin Street is officially recognized by the *Guinness Book of Records* as the world's steepest
residential street. For every 2.86 metres travelled horizontally, the elevation changes by 1 metre.
It is located in the residential suburb of North East Vallery, just outside Dunedin's city centre.

The biggest film set in the world.

Soaring mountain peaks, bubbling hot lakes, volcanoes, and crystalline glaciers make New Zealand one of the most evocative and exotic of locations for filmmakers.

Whether looking for a futuristic other-worldly atmosphere, as in *Avatar*, or a strange unknown land for the remake of *King Kong*, or a mystical setting for *The Lord of the Rings* epics, or a dramatic backdrop for movies as diverse as *The Piano*, or *X Men Origins: Wolverine*, New Zealand provides unrivalled scope for big-budget Hollywood productions.

New Zealand also possesses a geological and biological diversity that make it a once in a lifetime destination for tourists.

As a landmass it was isolated for 80 million years, resulting in peculiar birds that managed to develop due to the lack of mammalian predators, such as the national icon, the Kiwi; another native of New Zealand, the Moa, was one of the largest birds in history, standing at 3.6 metres tall and weighing 300kg.

These were inevitably hunted to extinction.

This richness of nature is not confined to the land, with almost half the world's whales, dolphins and porpoises to be found in New Zealand's waters. Nestled in the belly of the Pacific Ocean, it remains one of the most isolated locations on the planet, and for that reason was one of the last lands to be settled by humans.

Early Polynesian tribes arrived there in 1250, travelling hundreds of miles in waka, their canoes, across vast oceans. Once landed they developed Maori culture, which remains at the core of New Zealand tradition.

Europeans arrived four hundred years later with the Dutch seafarer Abel Tasman who first sighted the country in 1642 and named it Staten

Landt, thinking it was connected to South America.

James Cook was the next plucky seaman to make it to these distant shores, and subsequently anglicized Tasman's new name Nova Zeelandia, to New Zealand. In his circumnavigation, Cook discovered it to be an independent chain of islands, unconnected to Australia.

With Cook came colonization, and consequently the Maori were introduced to disease, guns and potatoes. Both of the latter led to escalating disputes and clashes amongst the Maori tribes, resulting in a forty-year period of fighting called the Musket Wars, decimating the numbers of Maoris in New Zealand.

In 1840, with instability and criminality rife in the country, the Treaty of Waitangi was signed, making New Zealand a colony of the British Empire.

In 1893 the country became the first in the world to give women the right to vote. Colonial accounts of the Maori tribes record a warrior culture of extreme ferocity, marked by cannibalism, female infanticide and prostitution. Early travelers to New Zealand observed that there were a noticeable disparity between the numbers of men and women, due to the fact that women would often kill their baby girls as they were considered less useful to the tribe than a future male combatant, and an additional strain on the family.

The Maori way of life must have been appealing to some, however. In the 1800s escaped convicts from Australia, and runaway sailors, would 'go native'. They were valued by their adoptive tribe as they brought knowledge of European technologies with them – especially in firearms.

Maoris, and Samoans have also been instrumental in the success of the mighty All Blacks rugby team of New Zealand.

Not surprisingly after their custom of screeching a terrifying Haka at their opponents, the All Blacks have held the top ranking in the world for longer than all other countries combined.

This warrior culture, beneficial on the rugby pitch, has created a

problematic network of Maori gangs, with some sources reporting that New Zealand has more gang members per head then any other country in the world, with about seventy major gangs and many thousands of members in a population of 4 million people. The most powerful of these are Black Power, the Mongrel Mob, Nomads and the King Cobras.

Unsurprisingly for a nation with so many mountains, one of the most famous New Zealanders is Sir Edmund Hillary. In 1953 Hillary and Sherpa Tenzing Norgay became the first climbers to reach the summit of Everest and survive.

Despite undertaking all manner of perilous adventures to the poles, and up mountains, Hillary's closest brushes with death came from plane crashes – one of which he avoided through being late for his flight, and the other by being replaced as a commentator, and not joining the ill-fated airliner carrying the documentary team to the Antarctic.

With a sincere love of altitude he would have approved of Baldwin Street in Dunedin, a town on the Southern Island, which is considered the world's steepest residential street, the slope of which rises at about 1 metre for every 2.86 metres travelled.

This provides the perfect location for competitions such as the Baldwin Street Gutbuster, where competitors have to run to the top of the hill and back down. Another event involves rolling 30,000 chocolate balls down the hill. There's not a lot to do in Dunedin.

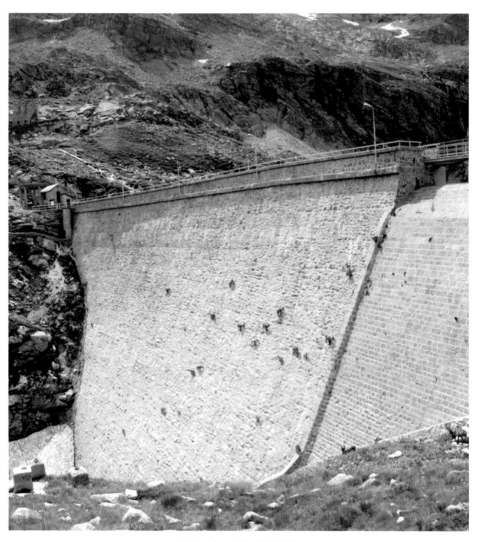

Cingino dam, Italian Alps, 2010

Cats can make cowards out of conquerors.

Dotted across the 160ft, near-vertical face of the Cingino dam are about twenty Alpine ibex goats, snapped by Italian hiker Adriano Migliorati.

The goats are used to these precarious grazing conditions; they are lured to the dam in order to lick the salt the rocks produce. With soft, split hooves that grip like pincers, they are very sure-footed.

I get vertigo when I reach rung four going up a ladder.

I don't like leaning out of high windows for a good look at the pavement below, nor peering down from even a second-floor balcony.

But I am perfectly comfy on airplanes, and have no other phobias that aren't perfectly normal, e.g. normal people don't like tarantulas or other poisonous spiders, and certainly nobody normal could like the idea of sharing a room with a deadly snake.

But you would be surprised at the phobias even manly men suffer from. George Washington was a brave General, risking his life on a number of occasions to save others. But he had a very fervent paranoia about being buried alive. He made his staff promise that his body would be left for two days after his death in case he was still actually living.

Premature burial was not unheard of in the sixteenth century, when medicine was more primitive, but by 1799 when Washington died, it was all but unknown.

My self-serving point?

You can apparently be utterly fearless, but still be crippled by a phobia or two.

Richard Nixon wasn't known as a girly man, but he was so scared of hospitals that when he had a blood clot in 1974, he outright refused to be taken to hospital because his excessive fear of the places made him feel that

if he were to ever enter one, he would never come out alive.

His doctor sedated him so heavily that he was unaware of being taken to hospital to be repaired, and underwent an operation surgeons knew was vital to save his life.

You wouldn't imagine anything much could frighten Alfred Hitchcock, director of the hauntingly gripping *Vertigo*, now top of many all-time greatest movie lists, as well as the thoroughly creepy *Psycho*.

But Hitchcock was very scared of eggs.

He had never tasted an egg in his entire life, and found it nauseating to even find himself near one. Nobody ever knew why.

Poor Sigmund Freud was able to analyse his own phobias only too effectively.

He was frightened of weapons, and theorised this was a repressed sign of retarded sexual and emotional maturity.

He was also scared of ferns but couldn't recall any traumatic childhood experiences that made ferns so challenging for him.

He died never being able to unearth the cause of this fear.

More prosaically, Oprah Winfrey has an enduring phobia of chewing gum.

Apparently, her grandmother would collect gum and keep it in rows in her cabinet.

Ms Winfrey was so revolted by watching this ritual that she ended up banning any gum-chewing in her television studio.

Even the audience for her shows respected her wishes and cooperated, so as not to startle her while filming.

Nikola Tesla was one of mankind's technical geniuses, a pioneering physicist, inventor of new uses for electromagnetism and responsible for a number of electrical breakthroughs.

But he was a committed germaphobe, who avoided touching people or anything else he felt could harbour germs, and would wash his hands frequently, obsessively and yes, compulsively.

He was also very frightened of jewellery, especially earrings that contained pearls.

Nobody could accuse Napoleon Bonaparte of being cowardly, and to all of us he is renowned as a fearsome military and political leader, the all powerful Emperor of France.

But he was simply terrified of cats, and they chilled him to the bone. Overcome with terror if he saw one, he would run feverishly away, or lock himself into a nearby room or cupboard.

What is it about dictators that made it so hard for them to get along with felines?

Hitler, Mussolini, even Julius Caesar shared Napoleon's quivering panic at the sight of a cat approaching too closely.

Despite Sigmund Freud's inability to analyse the cause of his fear of ferns, I am certain he could have cleared up this little mystery for us.

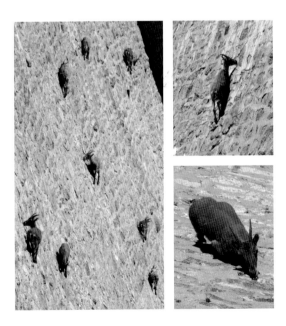

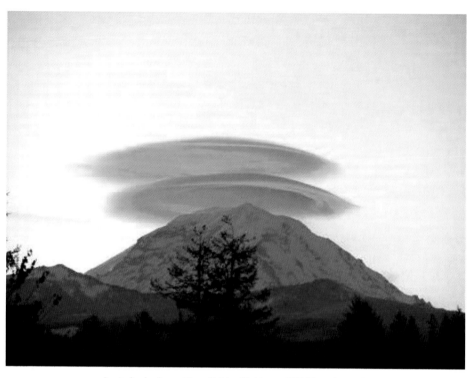

Lenticular clouds over Mount Rainier, Washington, USA, November 2004

These rarely seen clouds are formed by high winds blowing over rough terrain and are sometimes described as a stack of pancakes, or UFOs. In fact, in 1947 a pilot reported seeing nine flat objects flying in formation around the top of Mount Rainer. He claimed that the discs were moving at 1000mph "like a saucer skipping across water". Newspapers then coined the phrase "flying saucers".

What the UFO is that?

You may think they are delusional, and so may I. But apparently some quite sane, perfectly lucid, compellingly authoritative people are convinced about UFO sightings.

On 24th July 1948, two airline captains, both hardened World War II fighter pilots, Clarence Chiles and Charles Whitted, encountered a strange vehicle flying very closely alongside them. Both men claimed they got a good fifteen second look at it, that it was conical in shape, with two decks lined with windows, no wings, and a blinding light emitting from beneath the craft.

The pilots scrambled to their radio, asking air traffic control if there were any planes in the area, or anything experimental being tested – there was nothing known.

Air Force investigators started poking around and found a witness on the ground, Walter Massey, who worked as a member of ground crew at a nearby base, and had reported having seen the same object, an hour before Chiles and Whitted.

Perplexingly, they then discovered that the same craft, right down to the double row of windows, was spotted in the Netherlands, and had been reported a month earlier.

The military dismissed the encounter as a weather balloon, but eventually retracted that notion, and suggested it might have been a meteor. But the pilots rejected this theory, both having seen meteors before and knowing that they do not have windows.

The Air Force then concluded it was, in fact, an alien spacecraft, but the government's defence department rejected the report, pointing out that although nobody was certain about what the mysterious object was,

it didn't necessarily mean that it was an alien spacecraft.

I won't bore you with many more inexplicable sightings; groups of meteors that were tracked for days, moving far faster than any known jet aircraft, in a random pattern across the skies, witnessed by scientists, astronomers and military experts.

The giant parade unravelling in the sky above them was fittingly named, 'Project Twinkle'. At the height of the Cold War, it was the commonly held view that the Russians had developed a sinister new advanced vehicle, and were testing it over New Mexico, simply showing off to Americans as a propaganda-inspired scare tactic.

Today, the file on Project Twinkle is sealed, and nobody can offer an explanation.

The standard official response to UFO sightings is the ever reliable 'weather balloon'. Airline pilots reporting a mysterious experience of this kind are categorised as officially disorientated and probably flying erratically, causing a weather balloon to appear to zip back and forth around them.

Perhaps now is the moment to remind ourselves that UFO stands for Unidentified Flying Object. It doesn't mean aliens. It means unidentified.

But tell me please, is it just disorientation that makes so many U.S. astronauts and Soviet cosmonauts believe they have seen alien spacecraft on their journeys into space?

After the pioneering introduction of cinema by the Lumière Brothers, George Méliès made the first science fiction film in Paris in 1902, *A Trip to the Moon*. Our fascination with outer space, flying saucers, and alien abductions found their zenith in Hollywood's sci-fi heyday in the 1950s, but fantasy adventures like *Star Wars*, *Star Trek* and *Alien* are still widely popular today, far exceeding their early B-movie roots.

This image was shot on 7th July, 1999 by U.S. Navy Ensign John Gay. It shows how U.S. Navy Lt. Ron Candiloro's F/A-18 Hornet creates a shock wave as he breaks the sound barrier. The shock wave is visible as a large cloud of condensation formed by the cooling of the air. A smaller shock wave can be seen forming on top of the canopy. When the jet breaks the sound barrier it crashes through the shock waves – and the cloud – causing a sonic boom behind it.

Did Concorde's boom make it go bust?

Have you ever travelled fast enough to break the sound barrier?

I have many times, when I was resilient enough to take Concorde to New York for a mid-morning meeting, and be back overnight for another get-together the following day in London at 10 a.m.

You had to be insanely desperate to perform outstandingly at work to put up with this nonsense.

Fortunately, by the time Concorde was declared dead by British Airways in 2003, I was already well past the notion of full-on business buccaneering, and ready to be put out to pasture in the more agreeable world of piddling about with art exhibitions.

But I have exciting news for lovers of supersonic travel.

Researchers at M.I.T. have created fully-functioning computer models of an ultra-supersonic 'biplane' passenger jet, requiring less fuel and producing less of a sonic boom.

It was Concorde's shock waves that were claimed to create loud sonic bangs on the ground below the aircraft, as it broke the sound barrier.

The plane was banned from going full-pelt over land, as it would supposedly frighten and annoy people beneath its flight path.

This severely restricted its flexibility to fly most routes; it became irksome to divert so much effort to keep Concorde viable, as energy costs escalated, and it became clear that the real growth for airlines was to be in maximising low-cost flights.

Besides the sonic boom controversy, the boom in Concorde's popularity made it frustratingly ever more expensive to operate, as it carried too few passengers to cover the ever increasing rises in fuel costs.

The M.I.T. team's design is a jet with wings positioned on top of each

other, cancelling out shock waves at supersonic speeds and creating half the drag of Concorde, making it both quiet enough to travel over land, and simultaneously more economical at the petrol pumps.

Of course, observers contend that the opposition to Concorde on the grounds of noise pollution was encouraged by the U.S. government; they lacked their own American competitor, having cancelled development on the Boeing 2707 after spending a billion dollars on it.

Passenger planes had broken the sound barrier before Concorde.

A China Airline 747 broke the sound barrier in an unplanned and obviously very fast descent after an in-flight catastrophe caused it to plummet over four miles, before control was regained at the last moment, after the plane hit 5G as it careered downwards.

In the 1970s the Russian Tupolev Tu-144 airline claimed to have beaten Concorde to be the first commercial flight to pass through the sound barrier; however sceptics believed there were no passengers aboard, and that Concorde still merits the crown.

Today, the only large supersonic aircraft comparable to Concorde are strategic bombers, principally the Russian Tupolev Tu-22 and the American B-1 Lancer.

The Chinese have their own H-9 Stealth Bomber capable of Mach 3.7, three times Concorde's normal speed.

It would get you from London to New York in less than an hour, so not much time for a slap-up Chinese meal.

M.I.T. scientists are convinced that they are bringing back supersonic jet travel for a large number of passengers who will able to cross the globe at record speeds. A number will also be sold, I imagine, as private jets for Russian oligarchs, Asian billionaires, and Middle Eastern royalty.

Acknowledgements

Editorial Director and Designer: Georgina Marling
Copy Contributor: Natasha Hoare
Print and Design Consultant: Peter Gladwin
Author photograph by James King

Text © 2013 Charles Saatchi
©2013 Booth-Clibborn Editions
Reprint November 2013
Printed and Bound in China
ISBN 978-1-86154-340-0
All rights reserved.

Booth-Clibborn Editions has made all reasonable
efforts to reach artists, photographers and/or copyright
owners of images used in this book. We are prepared
to pay fair and reasonable fees for any usage made
without compensation agreement.

The information in this book is based on material
supplied to Booth-Clibborn Editions by the author.
While every effort has been made to ensure accuracy,
Booth-Clibborn Editions does not under any
circumstances accept responsibility for any errors or
omissions.

A Cataloguing-in-Publication record for this book is
available from the Publisher.

Booth-Clibborn Editions,
Studio 83,
235 Earls Court Road,
London SW5 0EB
Email:info@booth-clibborn.com
www.booth-clibborn.com

The author wishes to thank a number of websites and
other source material that have helped with research,
used verbatim where their clarity cannot be improved.

www.bbc.co.uk
www.blastr.com
www.cracked.com - Jacopo Della Quercia
www.cracked.com - Marc Russel
www.dailydawdle.com
www.didyouknowarchive.com
www.disinfo.com
www.dizzy-dee.com
www.extremescience.com
www.futilitycloset.com
www.gizmodo.com - Brent Rose
www.helpguide.org
www.howstuffworks.com
www.huffingtonpost.com/news/urlesqu
www.imgdumpr.com
www.listverse.com
www.mentalfloss.com
www.misconceptionjunction.com
www.news.discovery.com
www.null-hypothesis.co.uk
www.odditycentral.com
www.parents.berkeley.edu
www.ponderabout.com
www.psychologytoday.com - Gretchen Rubin
www.psychologytoday.com - Dr Sam Margulies
www.quora.com
www.rawfoodinfo.com
www.secret-london.co.uk
www.seedmagazine.com - Joe Kloc
www.stevecarter.com
www.tastefullyoffensive.com
www.thescavenger.net - Erin Stewart
www.theweek.com
www.theworldgeography.com
www.thinkorthwim.com
www.toptenz.net
www.travelever.com
www.twistedsifter.com
www.wikipedia.org
www.wordnik.com
www.wordorigins.org

Image credits